BARACK OBAMA

Barack Obama, the 44th president of the United States, became the first African-American president in the country's history in 2008. Obama's father was of Kenyan descent while his mother hailed from Kansas. When Obama was 10 years old, he lived with his maternal grandparents in Hawaii, as his parents had divorced and did not live in the country any longer. Before moving in with his grandparents, he lived in Indonesia with his mother, where he learned the language and culture. In Hawaii, he went to school at Punahou Academy, where he graduated with academic honors in 1979 and additionally played and excelled at basketball.

Obama graduated from Columbia University in New York City in 1983 and graduated from Harvard Law School in 1991. In 1992 he married Michelle LaVaughn Robinson; the couple eventually had two daughters, Malia and Sasha.

He became the junior senator from Illinois in 2004, making him the third African-American senator since the Reconstruction period. That same year, he gave the keynote speech at the Democratic National Convention.

Obama won the presidency in 2008 by defeating Arizona senator John McCain and won re-election in 2012 by defeating former Massachusetts governor Mitt Romney. As president, Obama and his family welcomed two dogs, Bo and Sunny, who are both Portuguese Water Dogs.

CELEBRITY PHOTOGRAPHER

FERRELL E. PHELPS, JR.

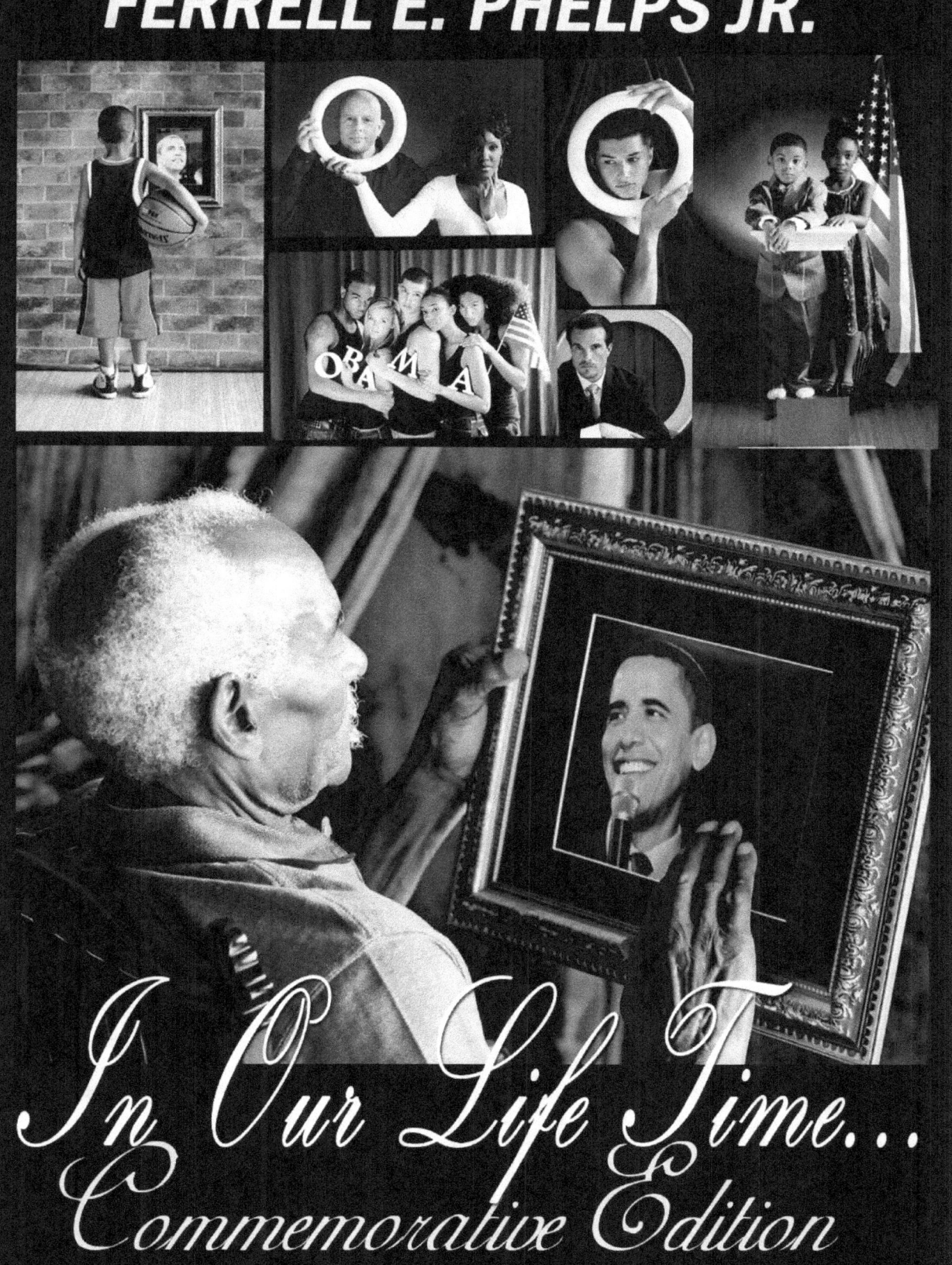

IN OUR LIFETIME
A Photographic Essay Tribute to
President Barack Obama

Ferrell E. Phelps, Jr.

Copyright © 2017 Ferrell E. Phelps, Jr.
All rights reserved.
ISBN: 9781545373491

COPYRIGHT 2017
ALL RIGHTS RESERVED

NO PART OF THIS PUBLICATION MAY BE REPRODUCED, STORED IN A RETRIEVAL

SYSTEM, OR TRANSMITTED IN ANY FORM OR BY ANY MEANS, ELECTRONIC, MECHANICAL, PHOTOCOPY, RECORDING, OR ANY OTHER, WITHOUT THE PRIOR PERMISSION OF THE AUTHOR.

DEDICATION

To my beautiful Mother Gladys Phelps

In Memory of my Father Ferrell E. Phelps, Sr.

My Grandmother Annie Bell Clay

&

My Friend Glenn Turner

ACKNOWLEDGEMENTS

My Family: Glady Phelps, George Phelps (Golden Boy) Sheila Foreman,

Lillian LeDay & Ronnie LeDay

Byron & Elizabeth Jackson

Pastors Rudy & Juanita Rasmus – St. Johns United Methodist Church, Houston, Texas

Mayor Sylvester Turner, Houston, Texas

Table of Contents

INTRODUCTION .. 6

INAUGURAL ADDRESS BY PRESIDENT BARACK OBAMA 9

YOU DID IT! MLK ... 18

OUR LEGACY LIVES ON ... 19

GOD BLESS AMERICA .. 22

AMERICA THE BEAUTIFUL ... 23

WHERE ARE THEY NOW? .. 27

I AM MICHELLE OBAMA ... 47

THE POWER OF O .. 49

SPECIAL THANKS ... 70

INTRODUCTION
Ferrell E. P helps, Jr.

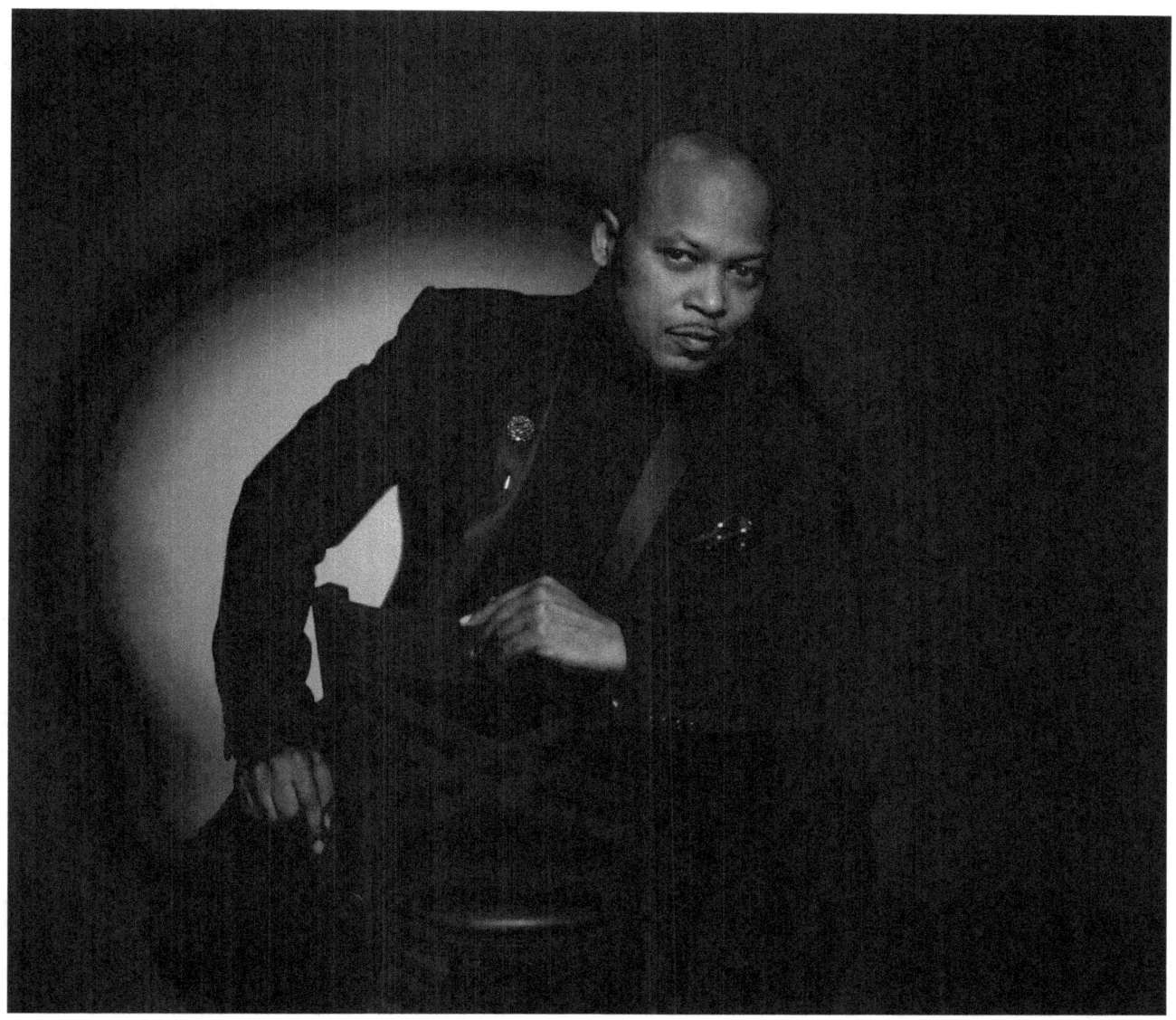

I remember speaking to my mother Gladys Phelps about the possibility that America could have a black President and she said wouldn't that be something I replied with a quick yes and then stated mom we'll have to go vote together let's do it, this is epic without a moment to breath she said yes. Ironically- yes, we can- was the slogan for the political campaign. Mom and I had many discussions leading up to the early

voting day as we anticipated what the atmosphere might be like at the polls.

Eight days away from early voting I entered my mom's room and said are you getting ready time is winding down she knew exactly what I was talking about, we both chuckled as I left her presence that day. In preparing for the early voting day I wondered what my father Ferrell E. Phelps, Sr. would say about all of this and mom mirrored that same thought she later said.

Well now the day has come and I've made certain to close my studio down for the day taking no appointments because I could not chance any type of delay or interruption on this day. Mom are you dressed yet it's almost time to be a part of this historical moment a day we both would never forget as she fancied up in her relaxed denim outfit and topped it all off with her favorite hat that adorned beautiful flowers that no one could sport as well her, I cleared the front seat of my vehicle and said come on let's do this she stated I'm ready as we drove to designated early voting location in a predominantly white area the lot was filled and we were looking at one another like oh boy get ready because it's going to be a long day but as I mentioned earlier I'd shut down my photography studio that day not knowing what to expect at the polls . We briskly exit the vehicle like 2 kids running to Santa (lol) trying to scurry to get in that long history in the making line (smiling) we arrived looked at each other and said whew we made it then we look further ahead to see what we thought was the end of the line was only less than half way but nothing was going to stop us from getting this job done on this day so we shifted from side to side in our stance moving 2 feet ahead every 5 minutes (lol). we finally reached our voting machine she went one way I had to go the other then we met up afterwards laughing and said its done all we can do is wait. Ironically

I knew prior to The winning of President Barack Obama because the holy spirit directed me to create the first volume of " In My Lifetime " before he won the presidency the photographic essay was completed and so many people questions why was creating the book and he's not yet president I would say the holy spirit guided me it blew many away but on the faithful day redemption took place leaving many in Awe of what I'd already spoken of and 8 years later the 2nd edition is in order honoring yet again our first African American President who now has 2 terms in the white house how epic is that . I am so excited to share this second edition with the world, why? because there is not another book in the world like it, so to all of you that get it you will I am offering you a one of a kind experience through art, photography, creativity, history vision and the blessing of what can happen when one man dreams!!!

-Ferrell E. Phelps, Jr.

The White House

Office of the Press Secretary

For Immediate Release

January 21, 2013

Inaugural Address by President Barack Obama

United States Capitol

11:55 A.M. EST

THE PRESIDENT: Vice President Biden, Mr. Chief Justice, members of the United States Congress, distinguished guests, and fellow citizens:

Each time we gather to inaugurate a President we bear witness to the enduring strength of our Constitution. We affirm the promise of our democracy. We recall that what binds this nation together is not the colors of our skin or the tenets of our faith or the origins of our names. What makes us exceptional -- what makes us American -- is

our allegiance to an idea articulated in a declaration made more than two centuries ago:

"We hold these truths to be self-evident, that all men are created equal; that they are endowed by their Creator with certain unalienable rights; that among these are life, liberty, and the pursuit of happiness."

Today we continue a never-ending journey to bridge the meaning of those words with the realities of our time. For history tells us that while these truths may be self-evident, they've never been self-executing; that while freedom is a gift from God, it must be secured by His people here on Earth. (Applause.) The patriots of 1776 did not fight to replace the tyranny of a king with the privileges of a few or the rule of a mob. They gave to us a republic, a government of, and by, and for the people, entrusting each generation to keep safe our founding creed.

And for more than two hundred years, we have.

Through blood drawn by lash and blood drawn by sword, we learned that no union founded on the principles of liberty and equality could survive half-slave and half-free. We made ourselves anew, and vowed to move forward together.

Together, we determined that a modern economy requires railroads and highways to speed travel and commerce, schools and colleges to train our workers.

Together, we discovered that a free market only thrives when there are rules to ensure competition and fair play.

Together, we resolved that a great nation must care for the vulnerable, and protect its people from life's worst hazards and misfortune.

Through it all, we have never relinquished our skepticism of central authority, nor have we succumbed to the fiction that all society's ills can be cured through government alone. Our celebration of initiative and enterprise, our insistence on hard work and personal responsibility, these are constants in our character.

But we have always understood that when times change, so must we; that fidelity to our founding principles requires new responses to new challenges; that preserving our individual freedoms ultimately requires collective action. For the American people can no more meet the demands of today's world by acting alone than American soldiers could have met the forces of fascism or communism with muskets and militias. No single person can train all the math and science teachers we'll need to equip our children for the future, or build the roads and networks and research labs that will bring new jobs and businesses to our shores. Now, more than ever, we must do these things together, as one nation and one people. (Applause.)

This generation of Americans has been tested by crises that steeled our resolve and proved our resilience. A decade of war is now ending. (Applause.) An economic recovery has begun. (Applause.) America's possibilities are limitless, for we possess all the qualities that this world without boundaries

demands: youth and drive; diversity and openness; an endless capacity for risk and a gift for reinvention. My fellow Americans, we are made for this moment, and we will seize it -- so long as we seize it together. (Applause.)

For we, the people, understand that our country cannot succeed when a shrinking few do very well and a growing many barely make it. (Applause.) We believe that America's prosperity must rest upon the broad shoulders of a rising middle class. We know that America thrives when every person can find independence and pride in their work; when the wages of honest labor liberate families from the brink of hardship. We are true to our creed when a little girl born into the bleakest poverty knows that she has the same chance to succeed as anybody else, because she is an American; she is free, and she is equal, not just in the eyes of God but also in our own. (Applause.)

We understand that outworn programs are inadequate to the needs of our time. So we must harness new ideas and technology to remake our government, revamp our tax code, reform our schools, and empower our citizens with the skills they need to work harder, learn more, reach higher. But while the means will change, our purpose endures: a nation that rewards the effort and determination of every single American. That is what this moment requires. That is what will give real meaning to our creed.

We, the people, still believe that every citizen deserves a basic measure of security and dignity. We must make the hard choices to reduce the cost of health care and the size of our deficit. But we reject the belief that America must choose between caring for the generation that built this country and investing in the generation that will build its

future. (Applause.) For we remember the lessons of our past, when twilight years were spent in poverty and parents of a child with a disability had nowhere to turn.

We do not believe that in this country freedom is reserved for the lucky, or happiness for the few. We recognize that no matter how responsibly we live our lives, any one of us at any time may face a job loss, or a sudden illness, or a home swept away in a terrible storm. The commitments we make to each other through Medicare and Medicaid and Social Security, these things do not sap our initiative, they strengthen us. (Applause.) They do not make us a nation of takers; they free us to take the risks that make this country great. (Applause.)

We, the people, still believe that our obligations as Americans are not just to ourselves, but to all posterity. We will respond to the threat of climate change, knowing that the failure to do so would betray our children and future generations. (Applause.) Some may still deny the overwhelming judgment of science, but none can avoid the devastating impact of raging fires and crippling drought and more powerful storms.

The path towards sustainable energy sources will be long and sometimes difficult. But America cannot resist this transition, we must lead it. We cannot cede to other nations the technology that will power new jobs and new industries, we must claim its promise. That's how we will maintain our economic vitality and our national treasure -- our forests and waterways, our crop lands and snow-capped peaks. That is how we will preserve our planet, commanded to our care by God. That's what will lend meaning to the creed our fathers once declared.

We, the people, still believe that enduring security and lasting peace do not require perpetual war. (Applause.) Our brave men and women in uniform, tempered by the flames of battle, are unmatched in skill and courage. (Applause.) Our citizens, seared by the memory of those we have lost, know too well the price that is paid for liberty. The knowledge of their sacrifice will keep us forever vigilant against those who would do us harm. But we are also heirs to those who won the peace and not just the war; who turned sworn enemies into the surest of friends -- and we must carry those lessons into this time as well.

We will defend our people and uphold our values through strength of arms and rule of law. We will show the courage to try and resolve our differences with other nations peacefully –- not because we are naïve about the dangers we face, but because engagement can more durably lift suspicion and fear. (Applause.)

America will remain the anchor of strong alliances in every corner of the globe. And we will renew those institutions that extend our capacity to manage crisis abroad, for no one has a greater stake in a peaceful world than its most powerful nation. We will support democracy from Asia to Africa, from the Americas to the Middle East, because our interests and our conscience compel us to act on behalf of those who long for freedom. And we must be a source of hope to the poor, the sick, the marginalized, the victims of prejudice –- not out of mere charity, but because peace in our time requires the constant advance of those principles that our common creed describes: tolerance and opportunity, human dignity and justice.

We, the people, declare today that the most evident of truths –- that all of us are created equal –- is the star that guides us still; just as it guided

our forebears through Seneca Falls, and Selma, and Stonewall; just as it guided all those men and women, sung and unsung, who left footprints along this great Mall, to hear a preacher say that we cannot walk alone; to hear a King proclaim that our individual freedom is inextricably bound to the freedom of every soul on Earth. (Applause.)

It is now our generation's task to carry on what those pioneers began. For our journey is not complete until our wives, our mothers and daughters can earn a living equal to their efforts. (Applause.) Our journey is not complete until our gay brothers and sisters are treated like anyone else under the law –- (applause) -- for if we are truly created equal, then surely the love we commit to one another must be equal as well. (Applause.) Our journey is not complete until no citizen is forced to wait for hours to exercise the right to vote. (Applause.) Our journey is not complete until we find a better way to welcome the striving, hopeful immigrants who still see America as a land of opportunity -- (applause) -- until bright young students and engineers are enlisted in our workforce rather than expelled from our country. (Applause.) Our journey is not complete until all our children, from the streets of Detroit to the hills of Appalachia, to the quiet lanes of Newtown, know that they are cared for and cherished and always safe from harm.

That is our generation's task -- to make these words, these rights, these values of life and liberty and the pursuit of happiness real for every American. Being true to our founding documents does not require us to agree on every contour of life. It does not mean we all define liberty in exactly the same way or follow the same precise path to happiness. Progress does not compel us to settle centuries-long debates about the role of government for all time, but it does require us to act in our time. (Applause.)

For now decisions are upon us and we cannot afford delay. We cannot mistake absolutism for principle, or substitute spectacle for politics, or treat name-calling as reasoned debate. (Applause.) We must act, knowing that our work will be imperfect. We must act, knowing that today's victories will be only partial and that it will be up to those who stand here in four years and 40 years and 400 years hence to advance the timeless spirit once conferred to us in a spare Philadelphia hall.

My fellow Americans, the oath I have sworn before you today, like the one recited by others who serve in this Capitol, was an oath to God and country, not party or faction. And we must faithfully execute that pledge during the duration of our service. But the words I spoke today are not so different from the oath that is taken each time a soldier signs up for duty or an immigrant realizes her dream. My oath is not so different from the pledge we all make to the flag that waves above and that fills our hearts with pride.

They are the words of citizens and they represent our greatest hope. You and I, as citizens, have the power to set this country's course. You and I, as citizens, have the obligation to shape the debates of our time -- not only with the votes we cast, but with the voices we lift in defense of our most ancient values and enduring ideals. (Applause.)

Let us, each of us, now embrace with solemn duty and awesome joy what is our lasting birthright. With common effort and common purpose, with passion and dedication, let us answer the call of history and carry into an uncertain future that precious light of freedom.

Thank you. God bless you, and may He forever bless these United States of America. (Applause.)

END
12:10 P.M. EST

FERRELL E. PHELPS, JR.

YOU DID IT! MLK

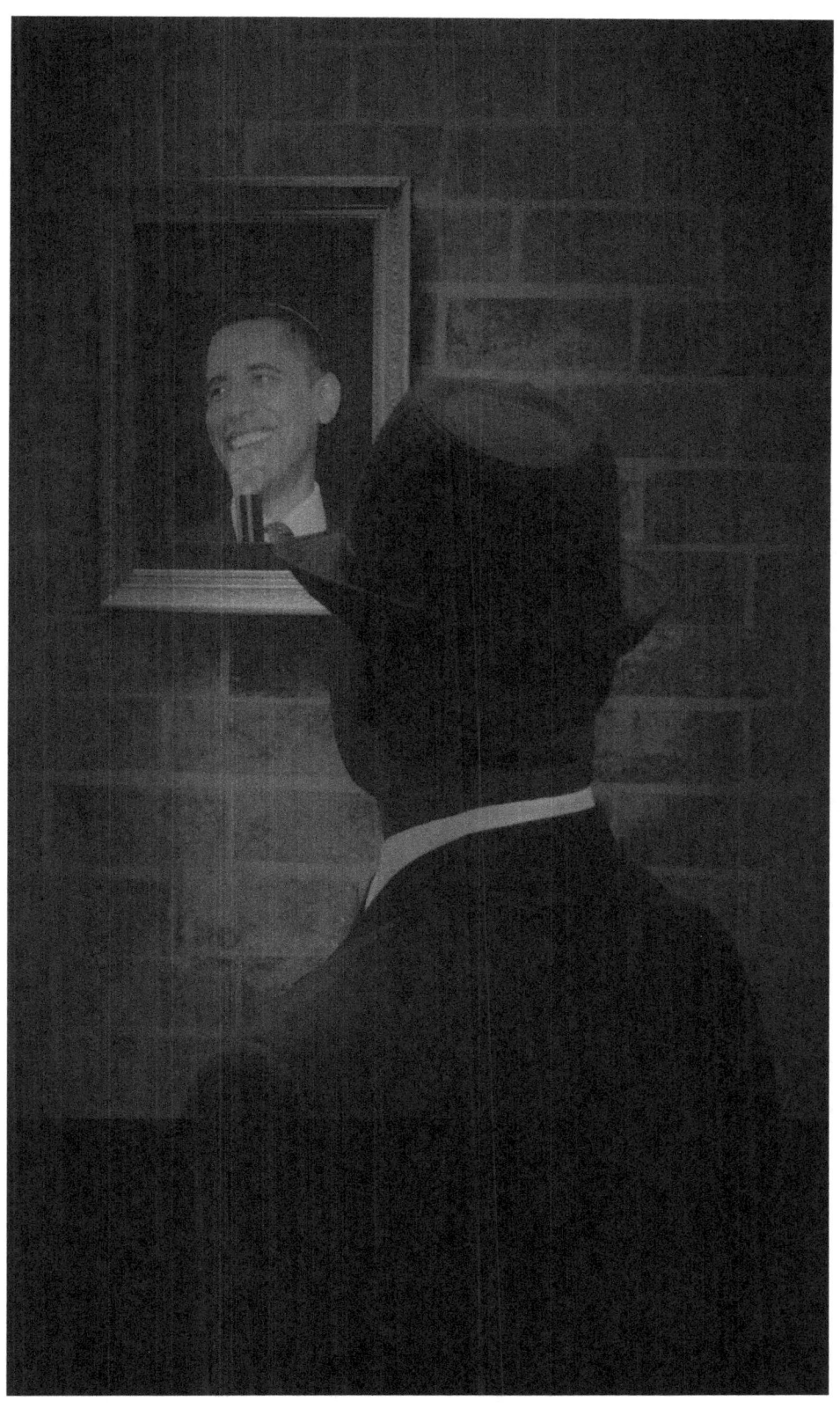

OUR LEGACY LIVES ON
MARTIN & CORETTA

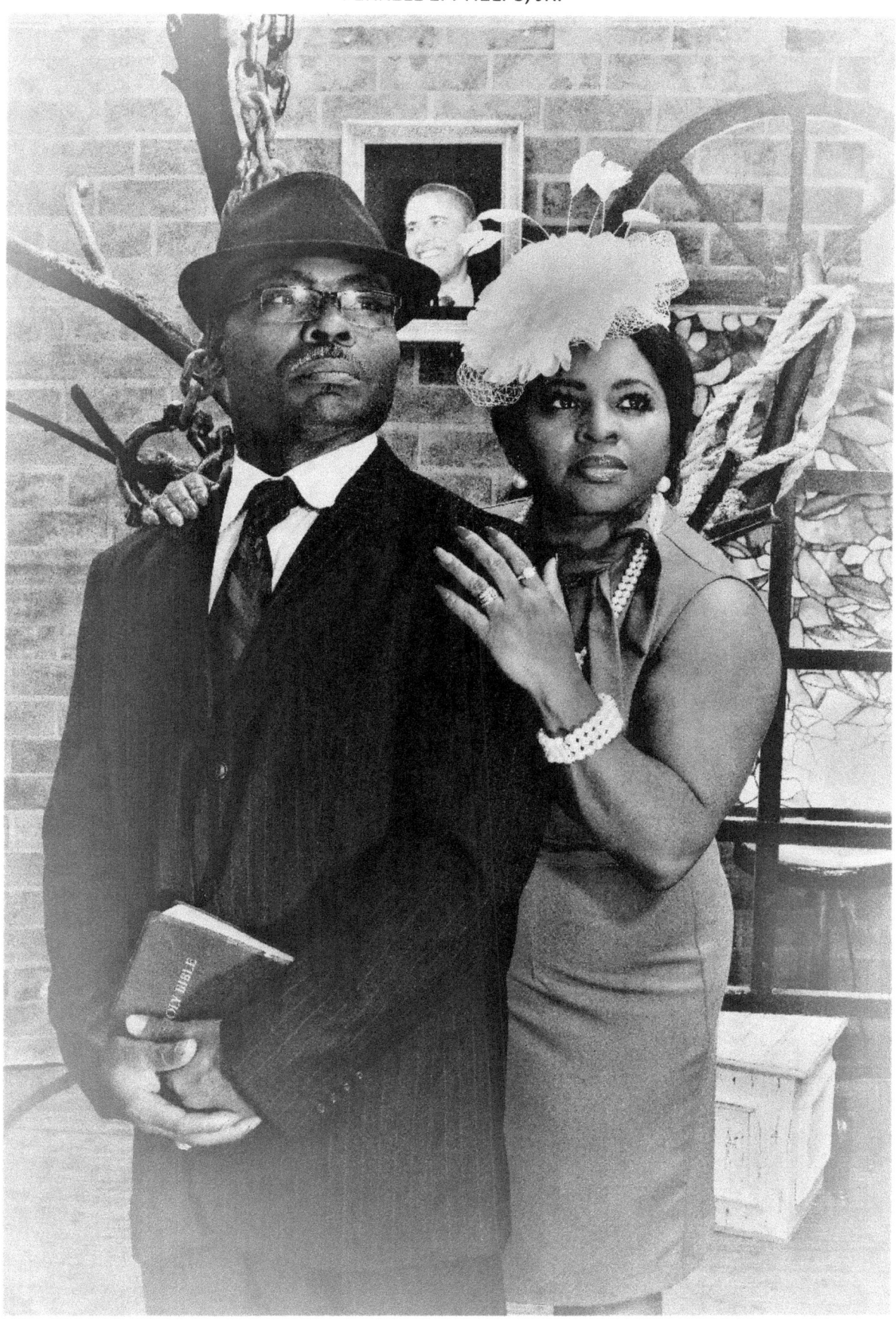

FERRELL E. PHELPS, JR.

GOD BLESS AMERICA

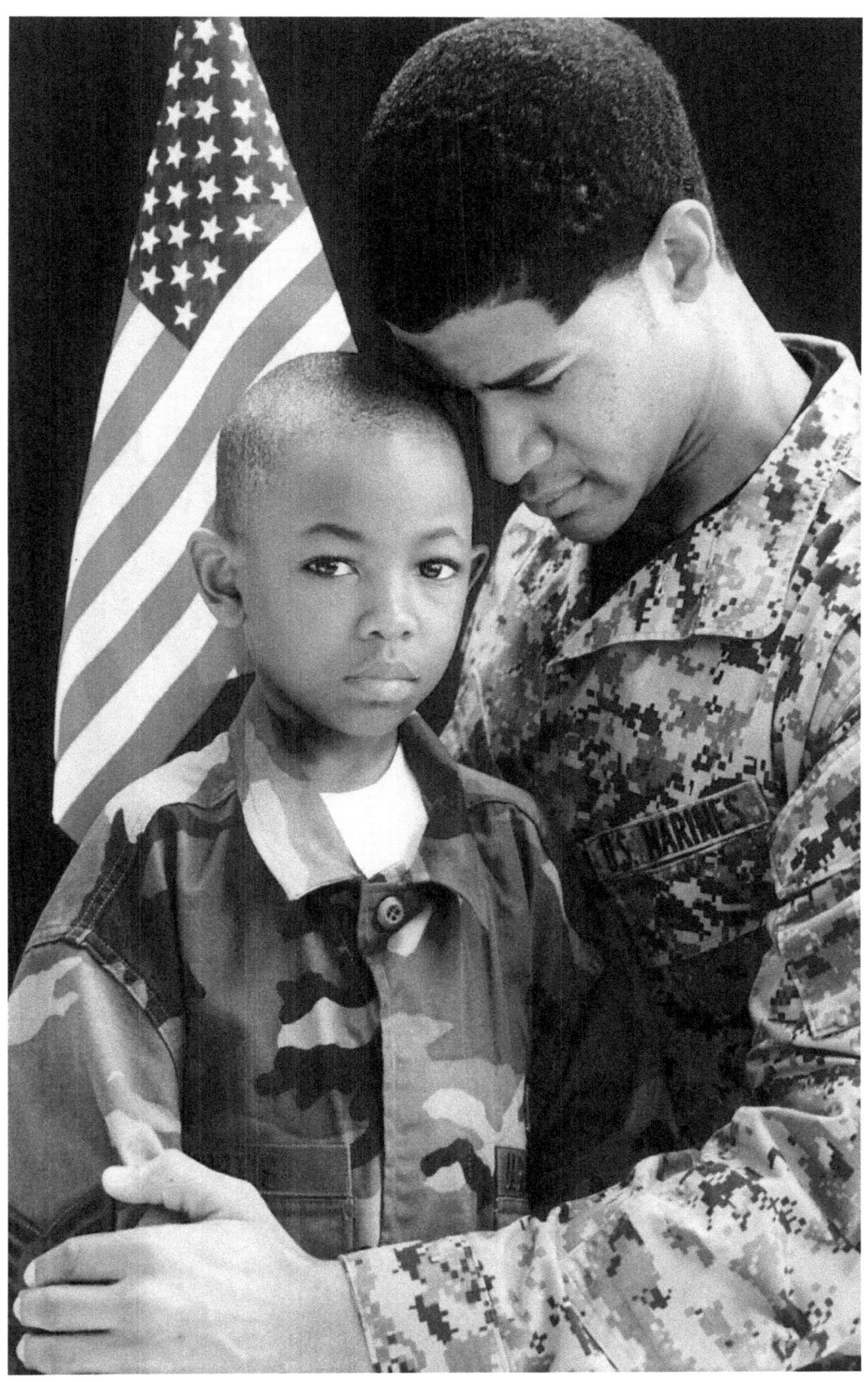

AMERICA THE BEAUTIFUL

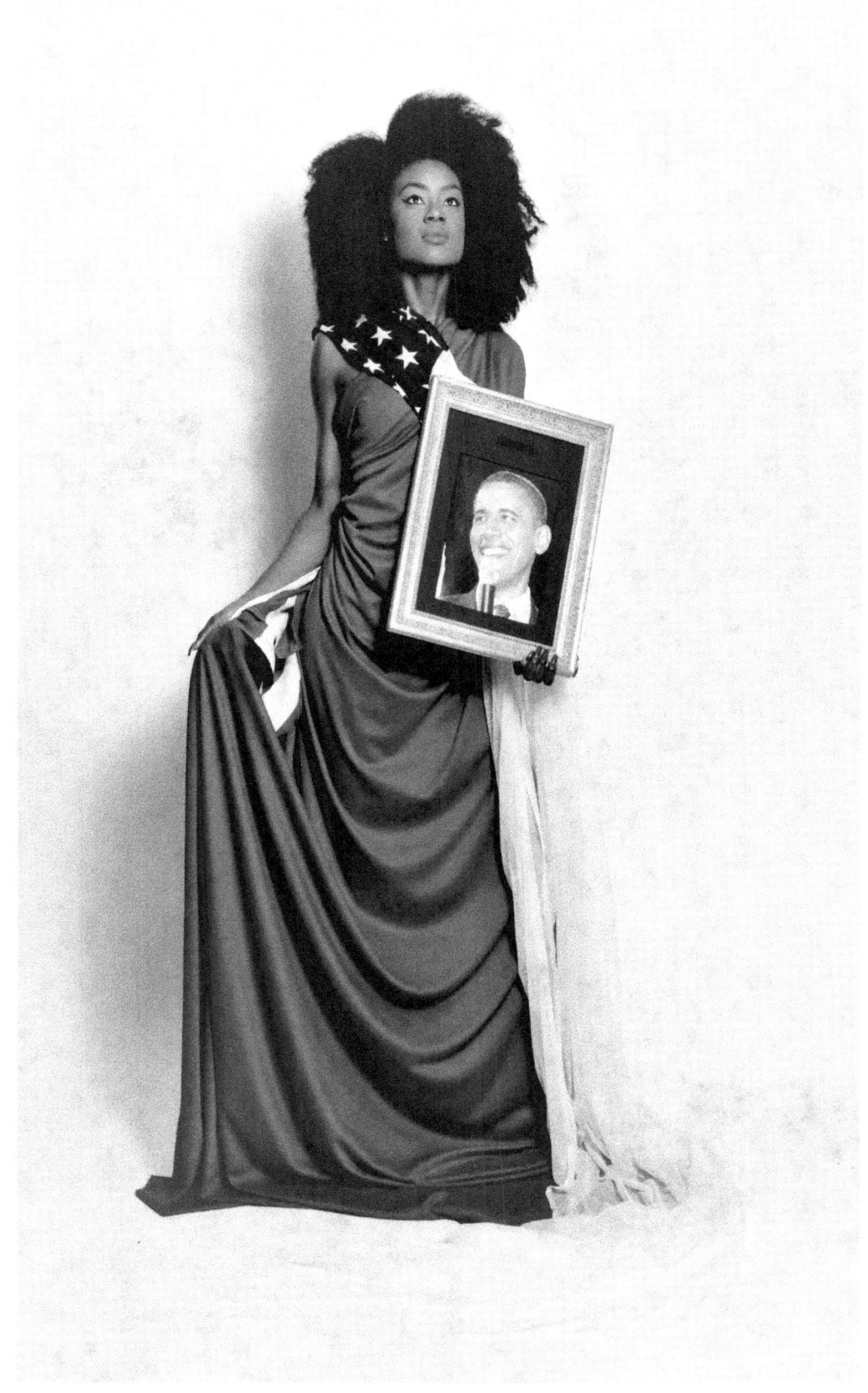

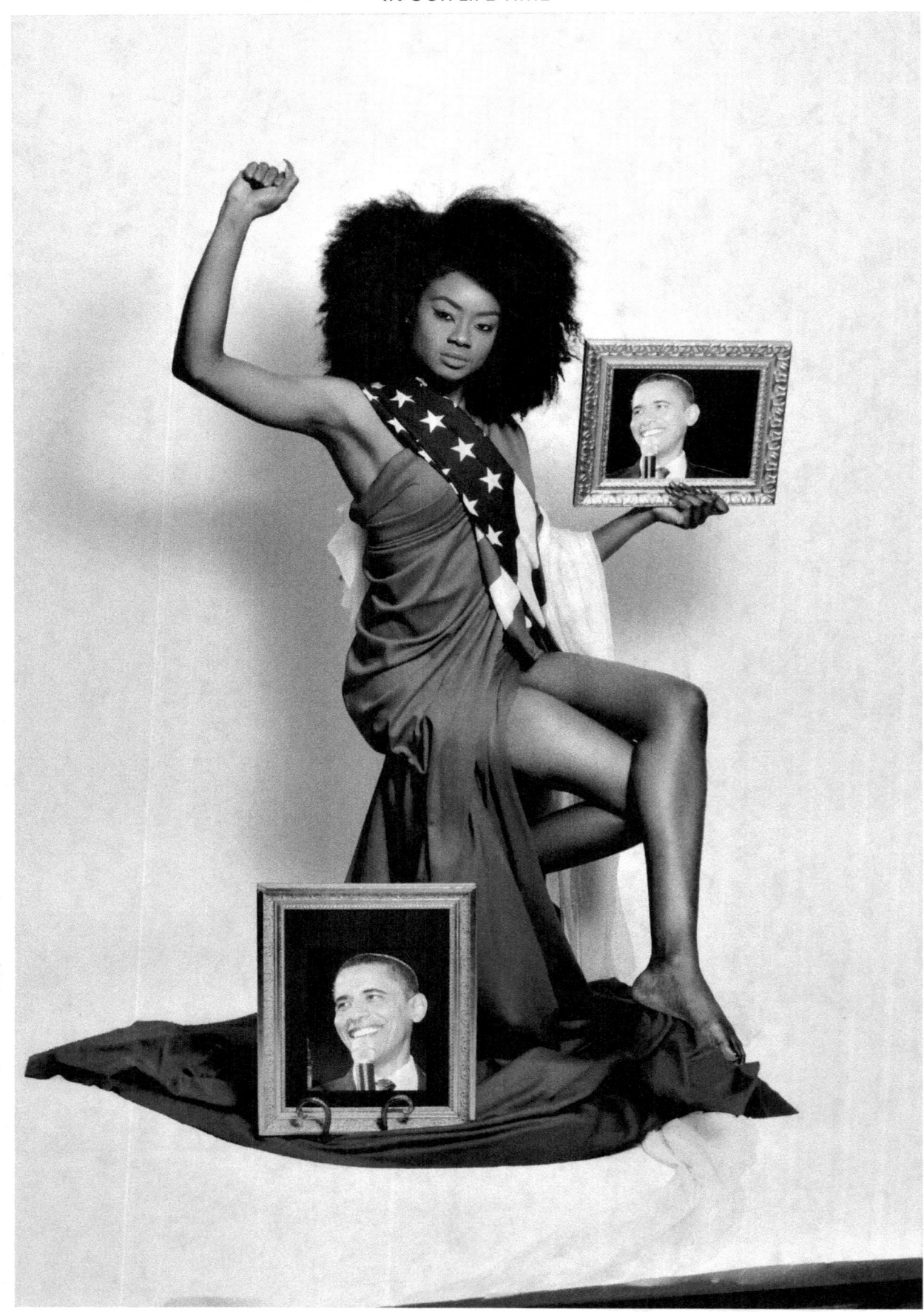

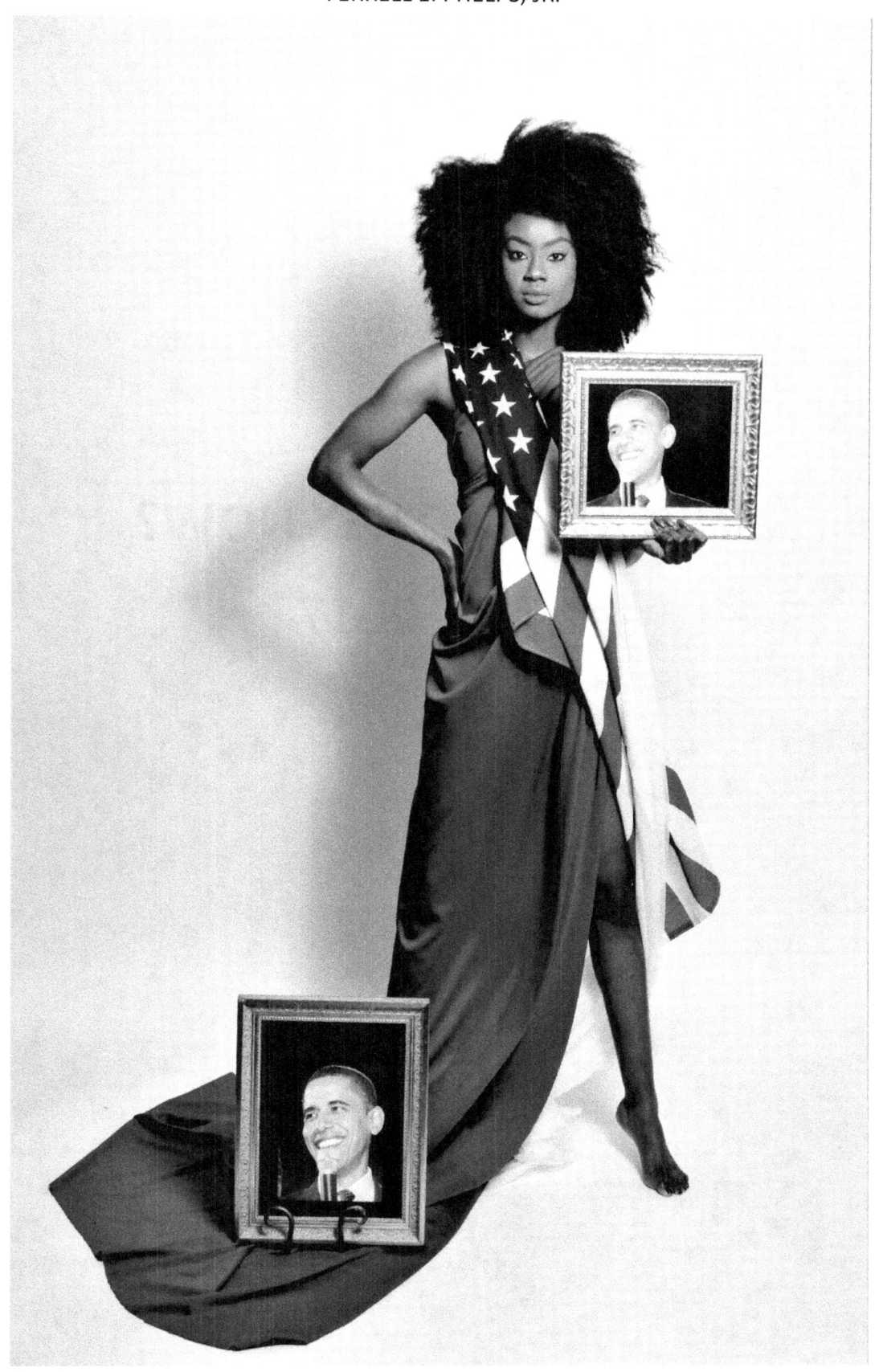

WHERE ARE THEY NOW?
2007 - 2017

2008 Twins Ma'kayla & Kateleen Kent Admiring President Elect Barack Obama

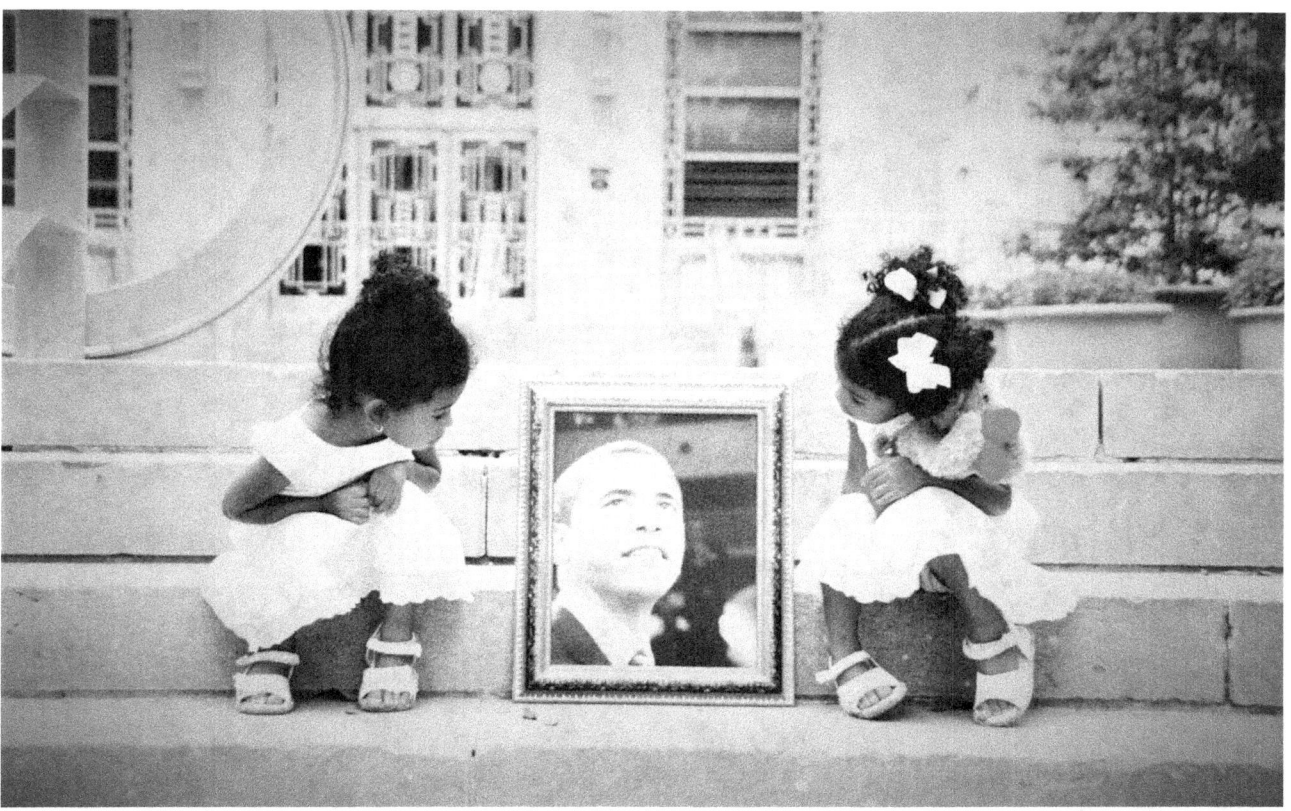

Job well done Mr. President!
2017 Twins Ma'kayla & Kateleen Kent

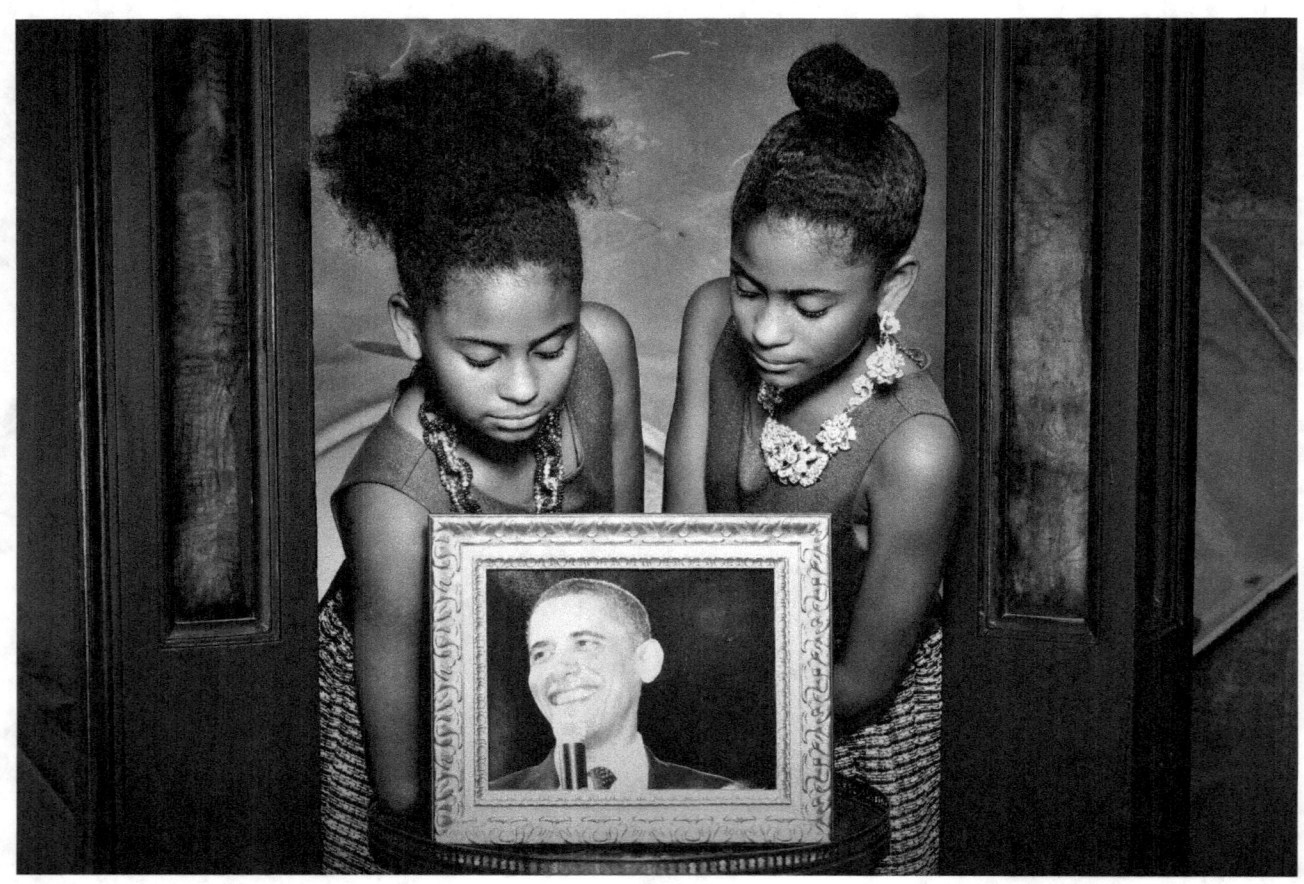

2017 Thumps Up Mr. President
Ma'kayla & Kateleen Kent

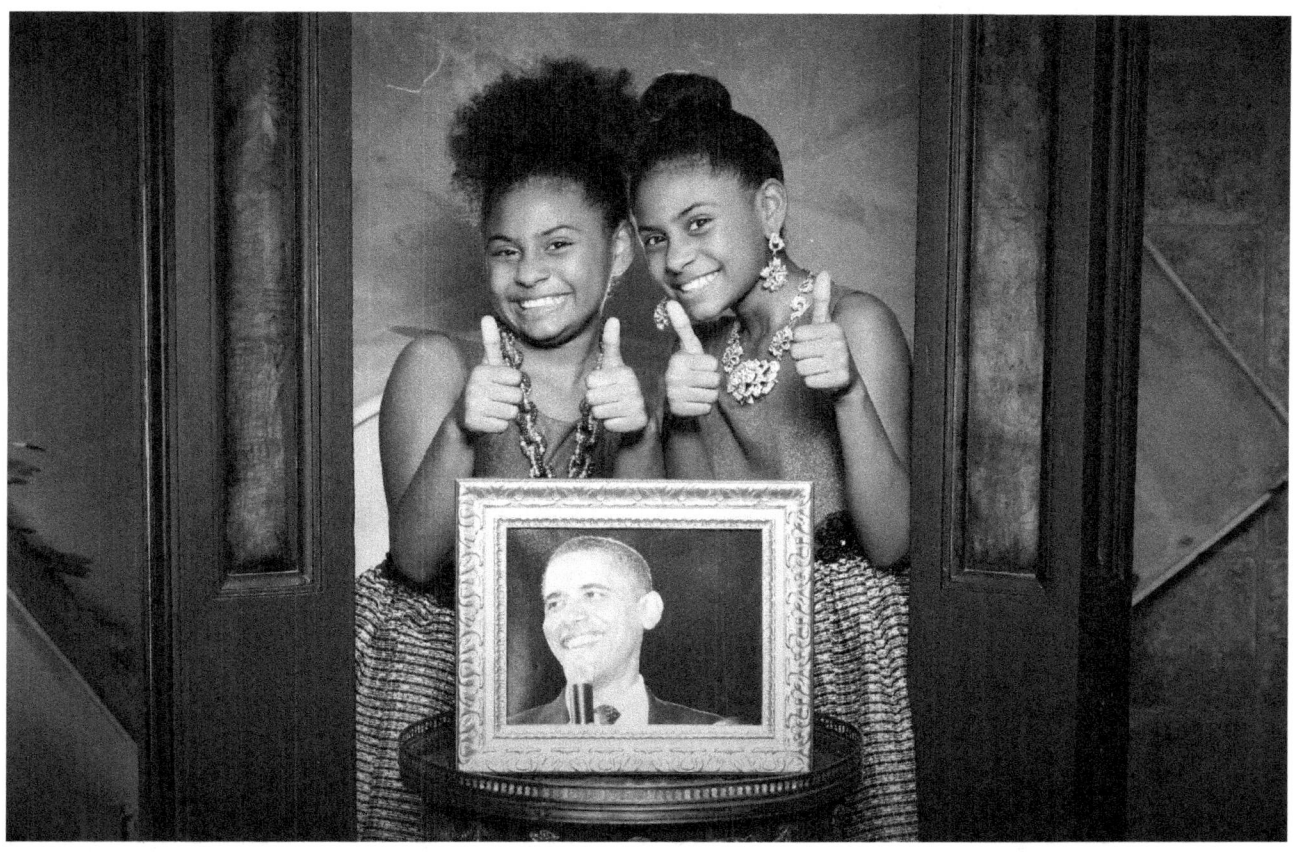

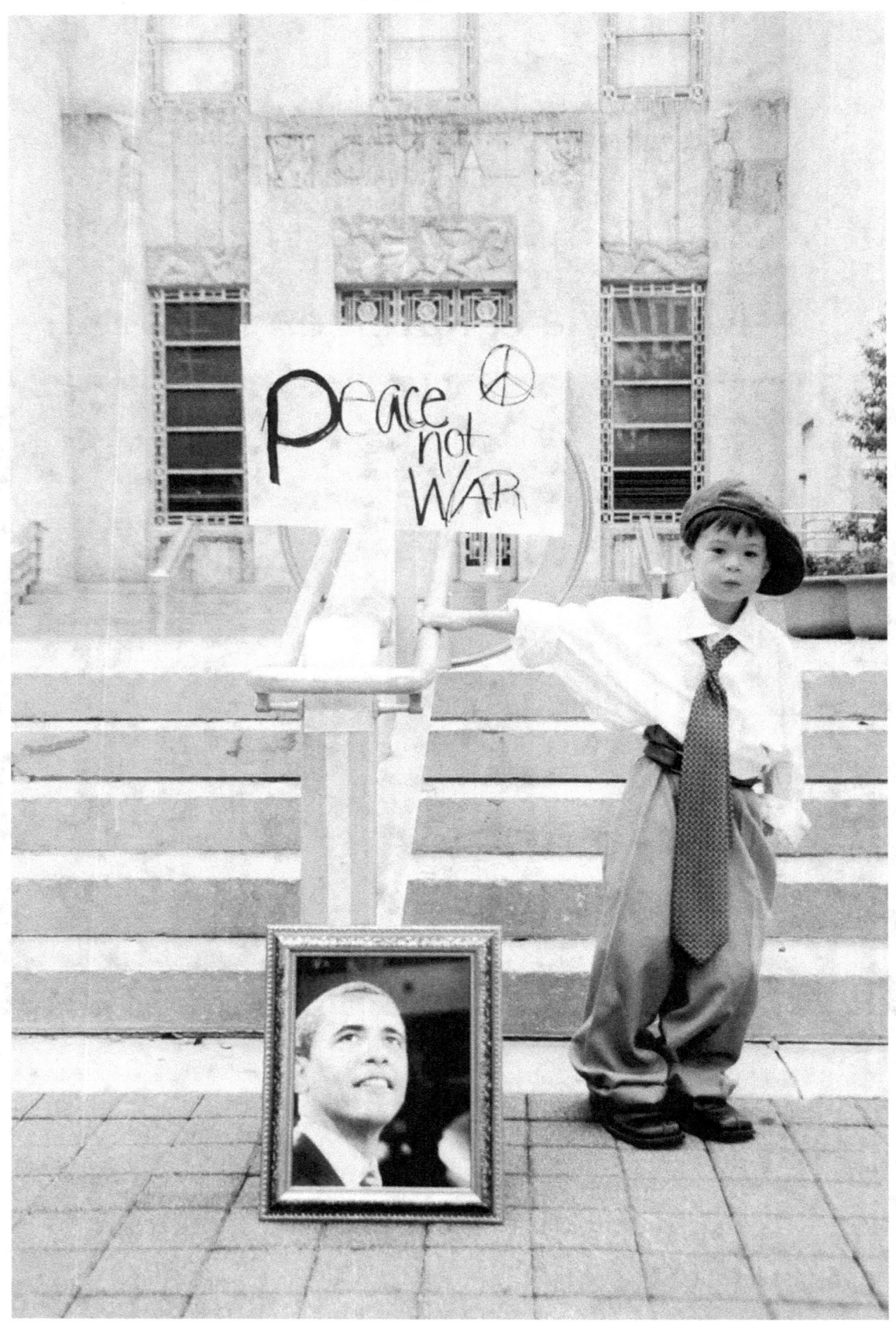

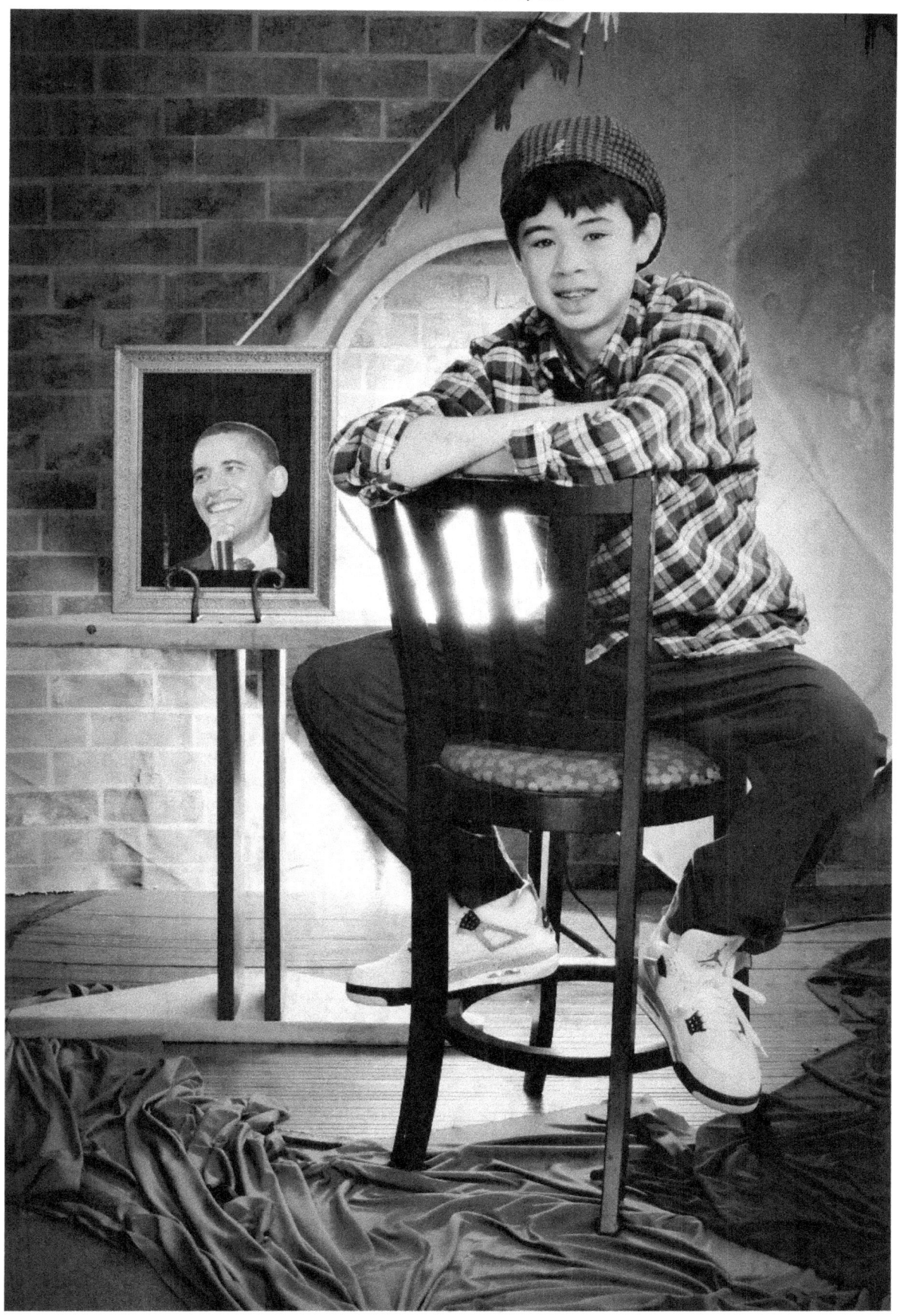

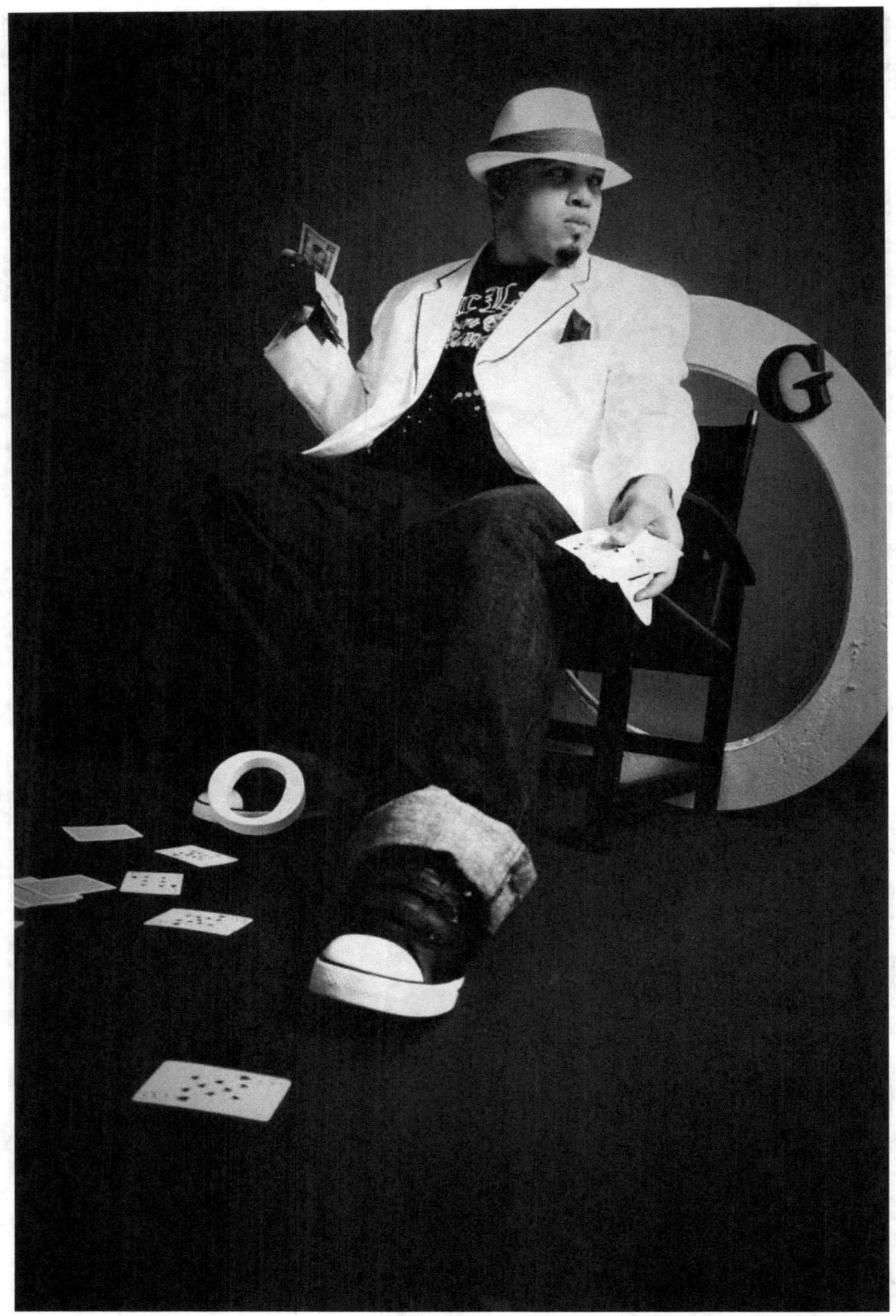

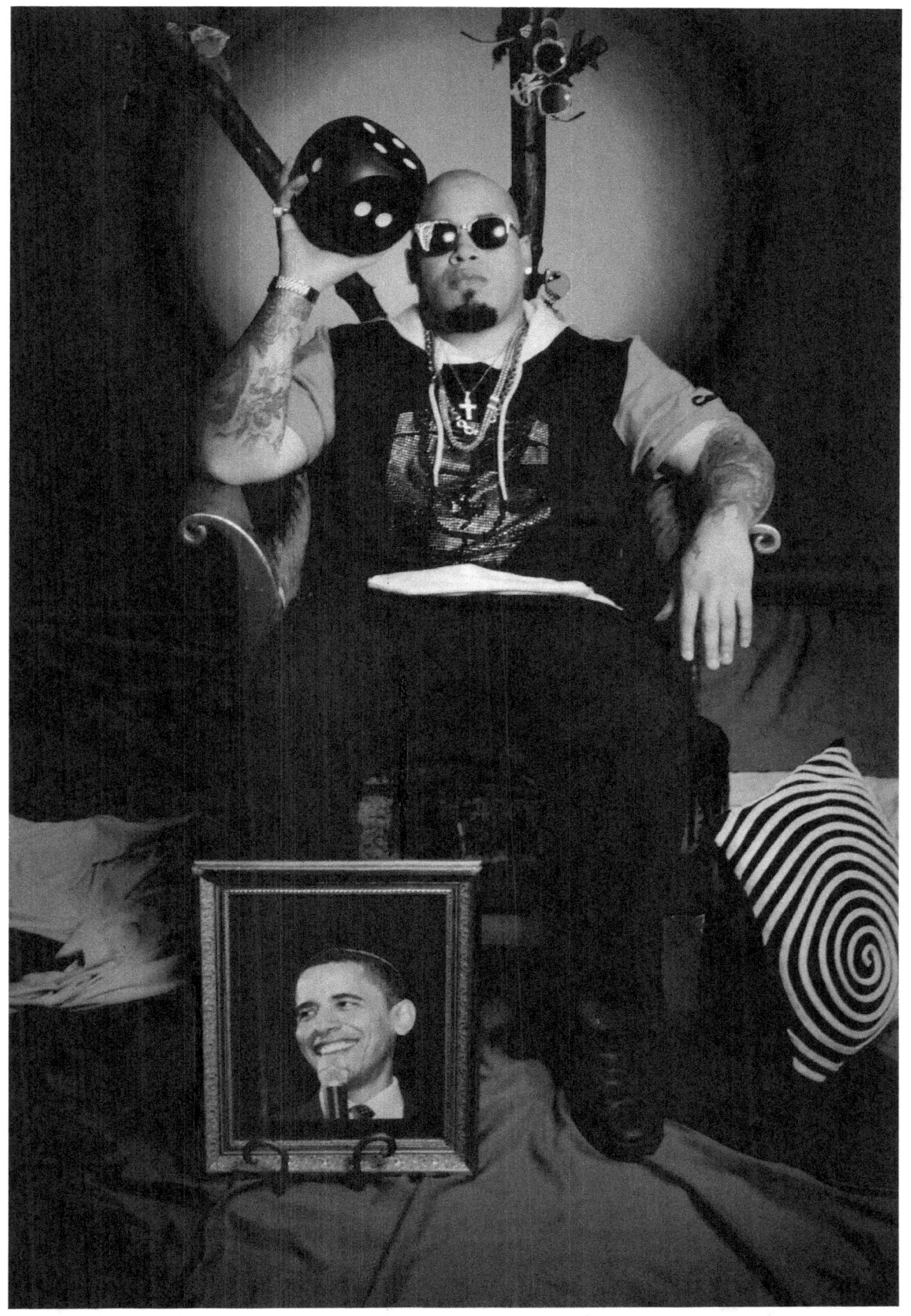

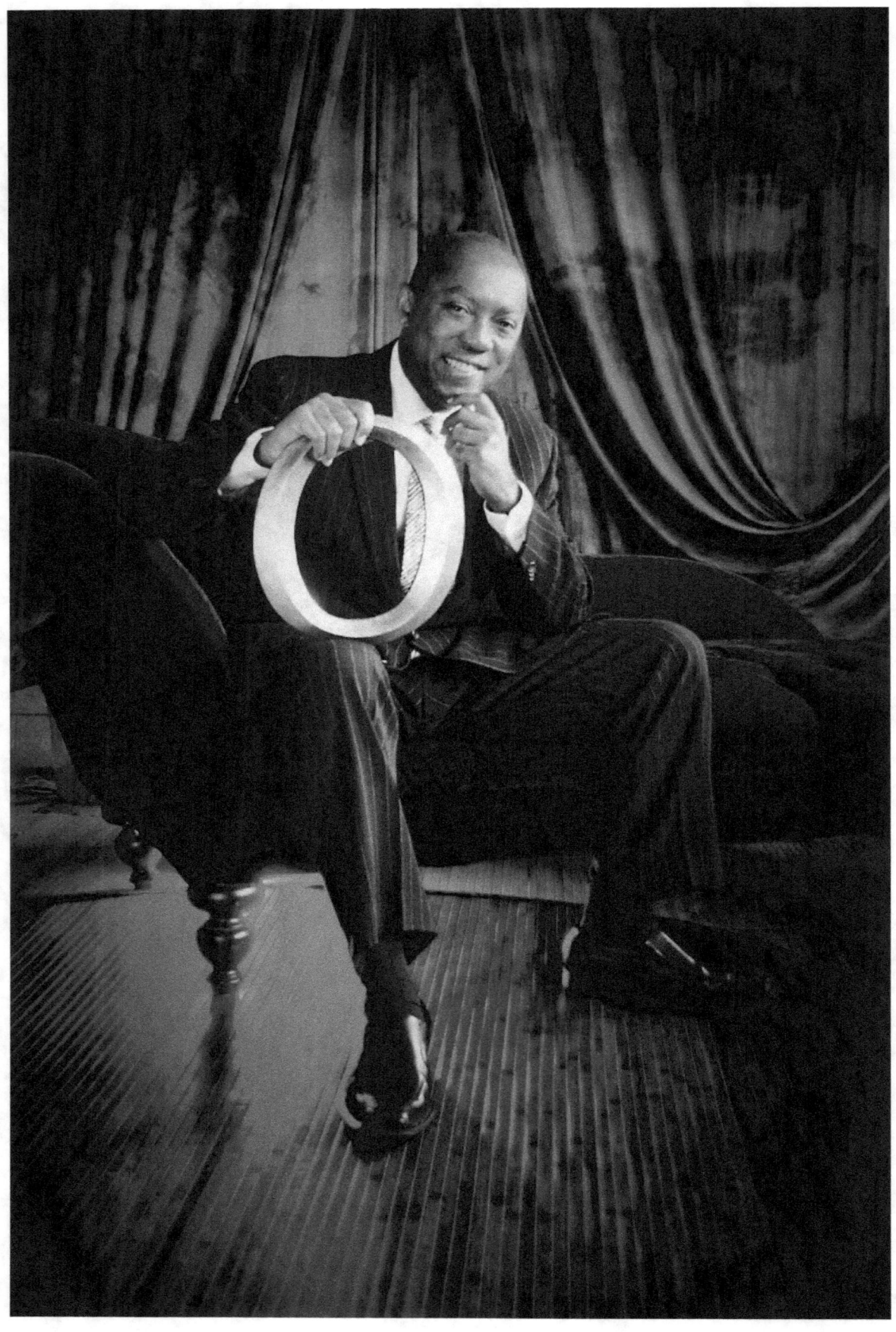

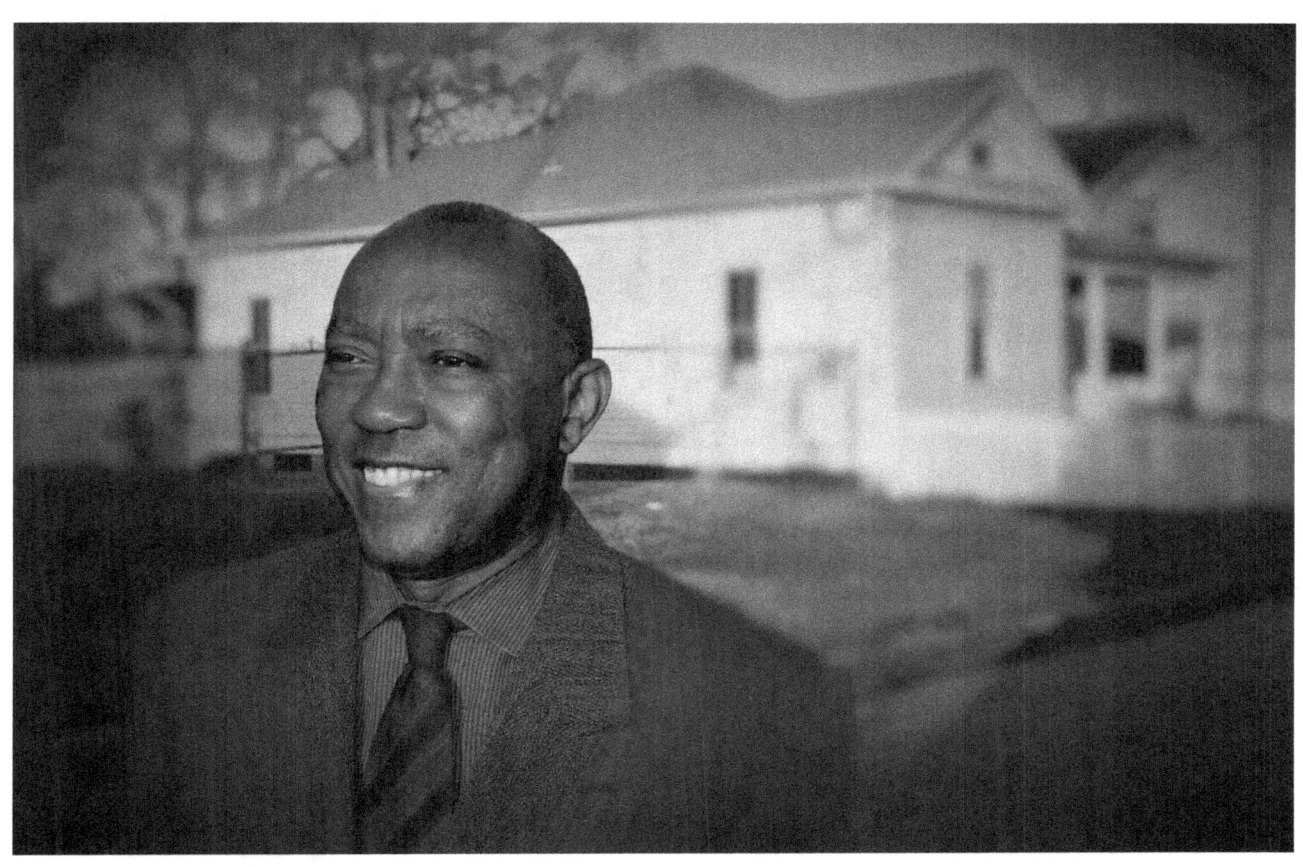

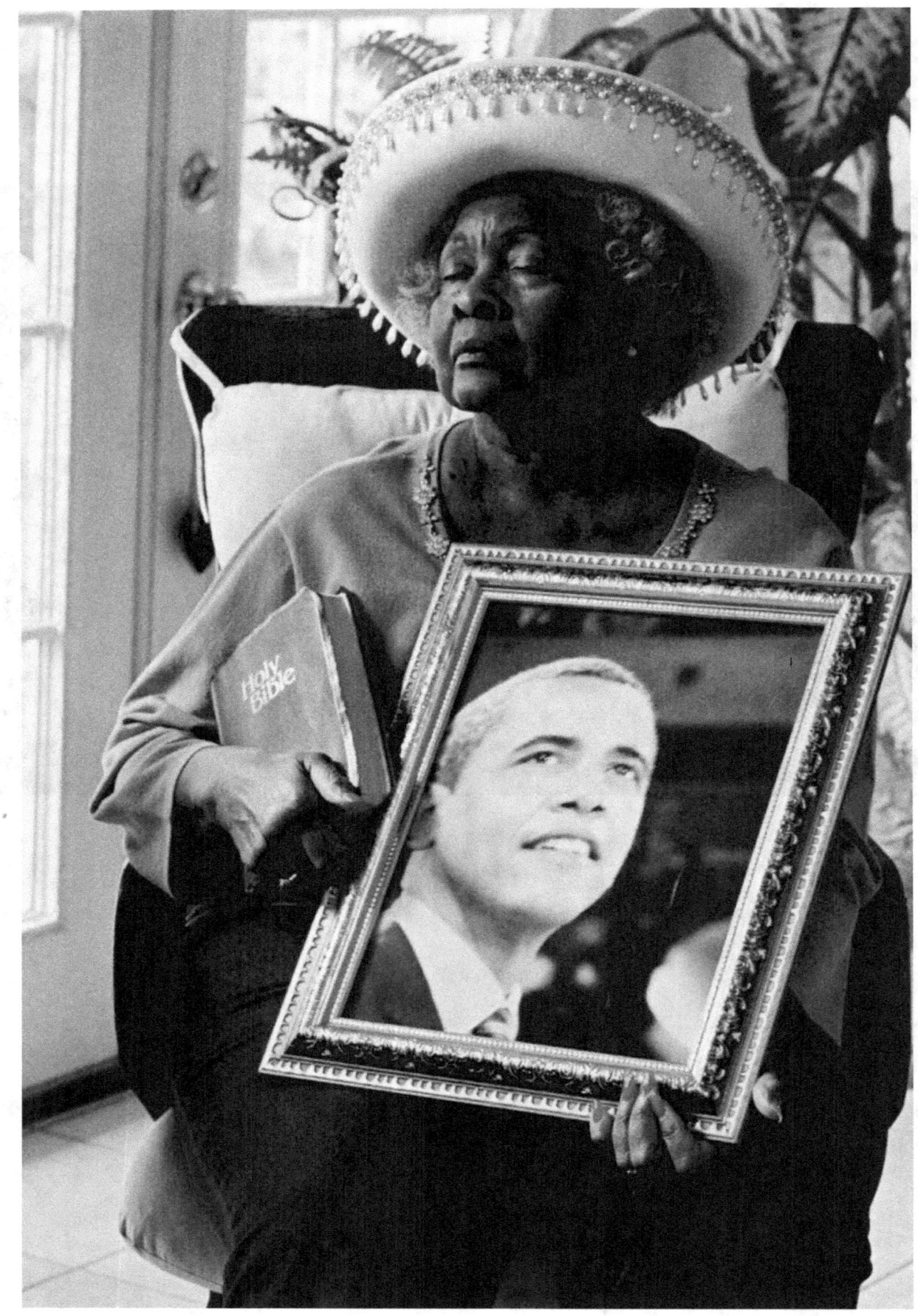

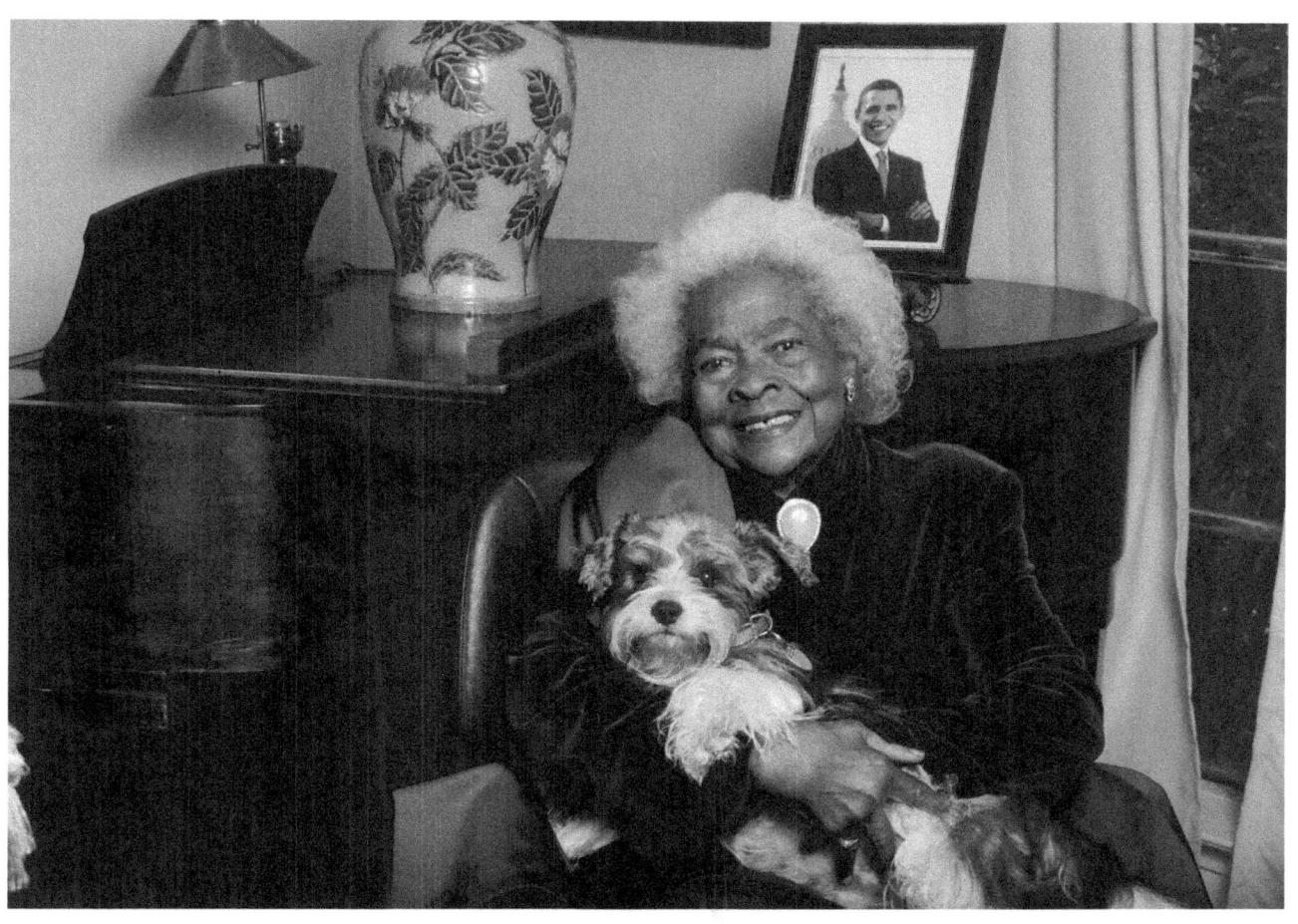

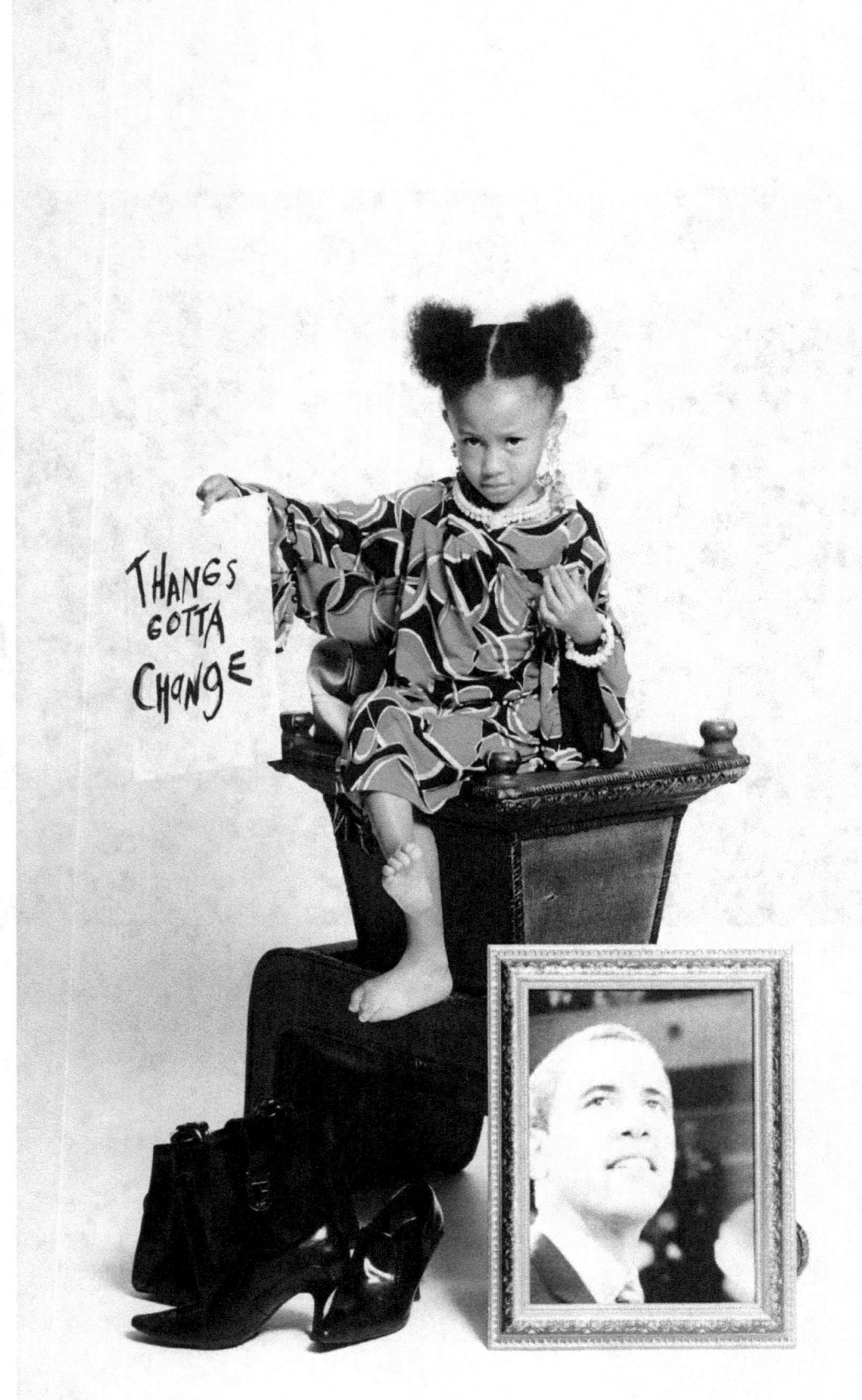

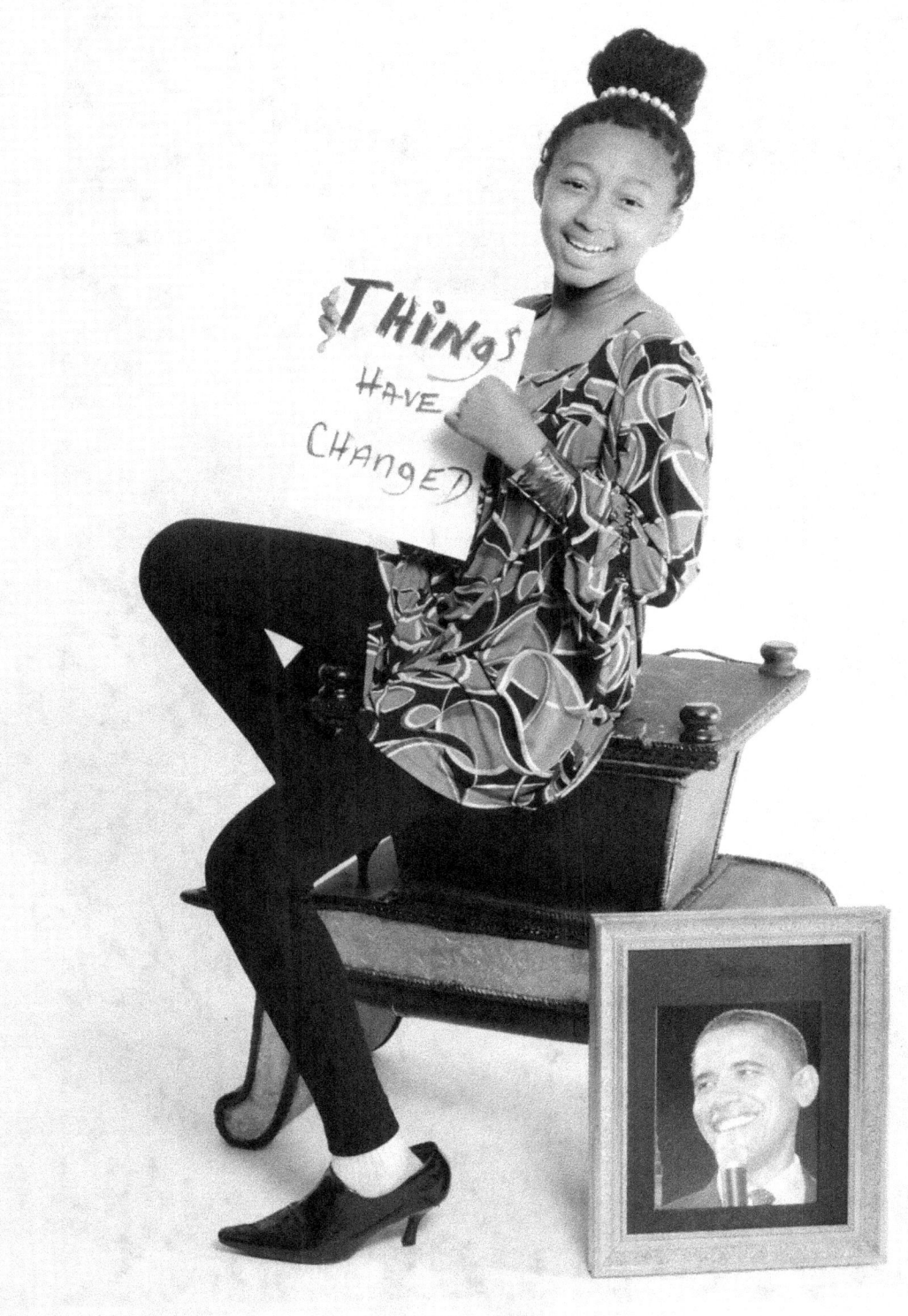

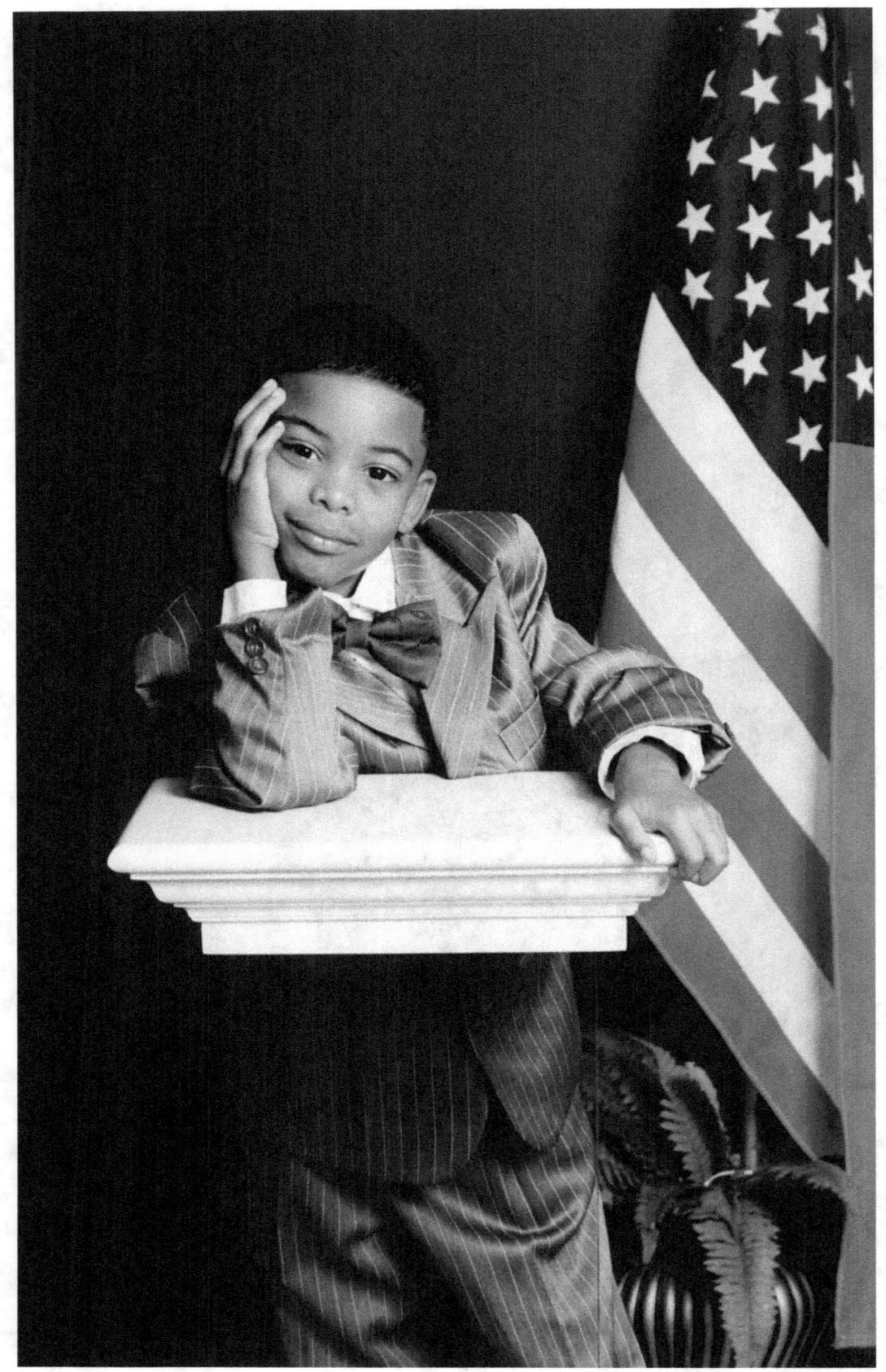

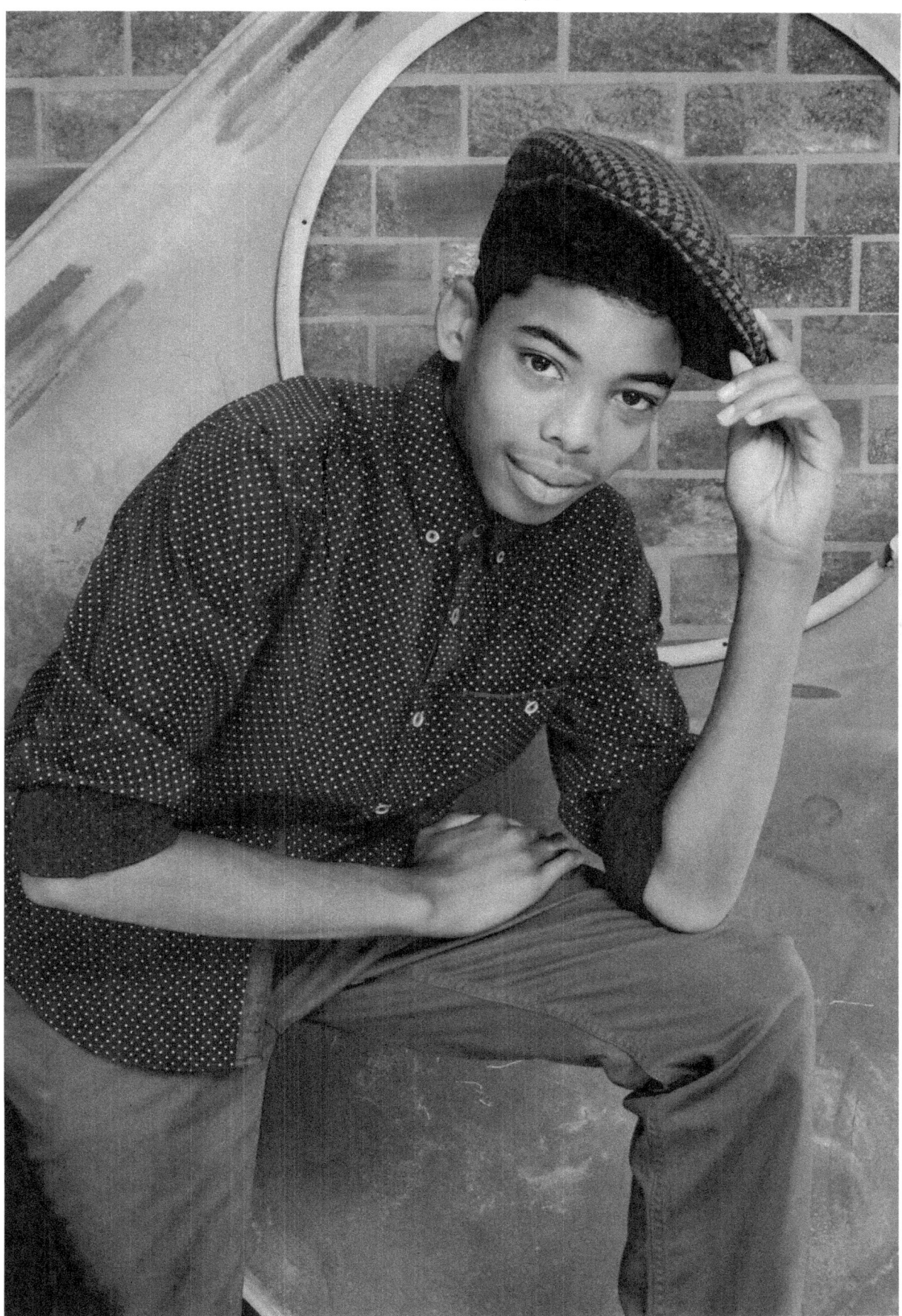

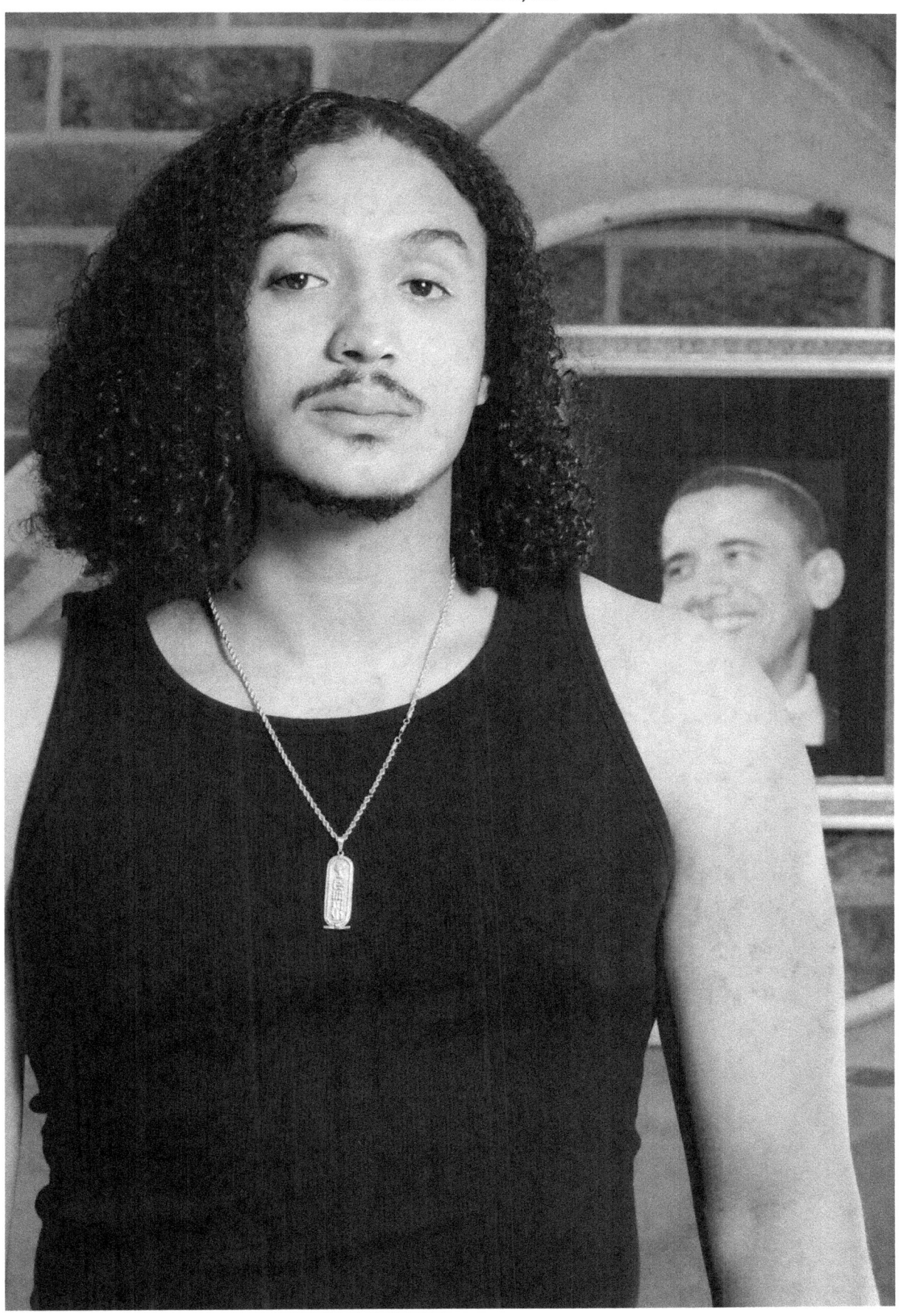

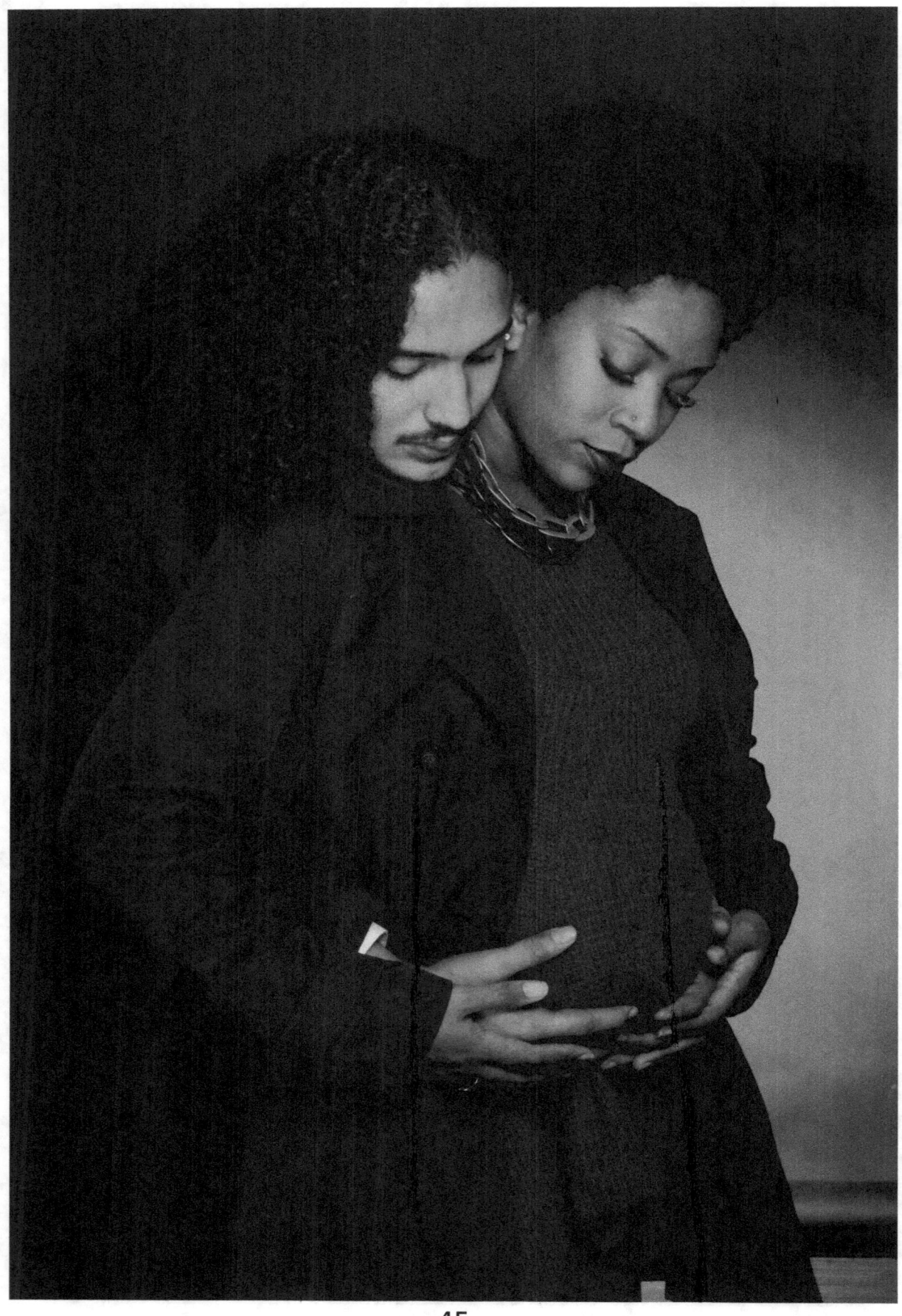

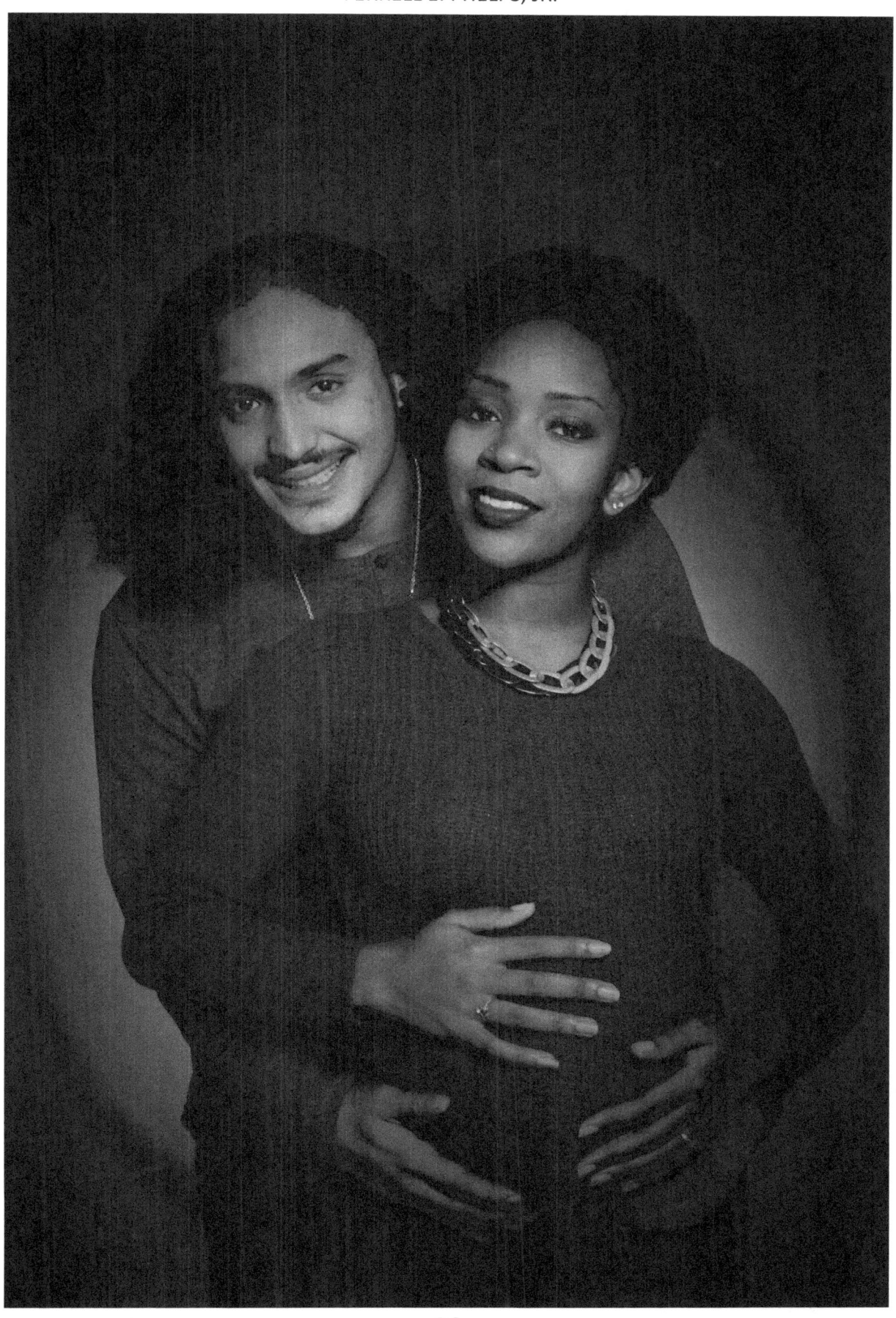

I AM MICHELLE OBAMA

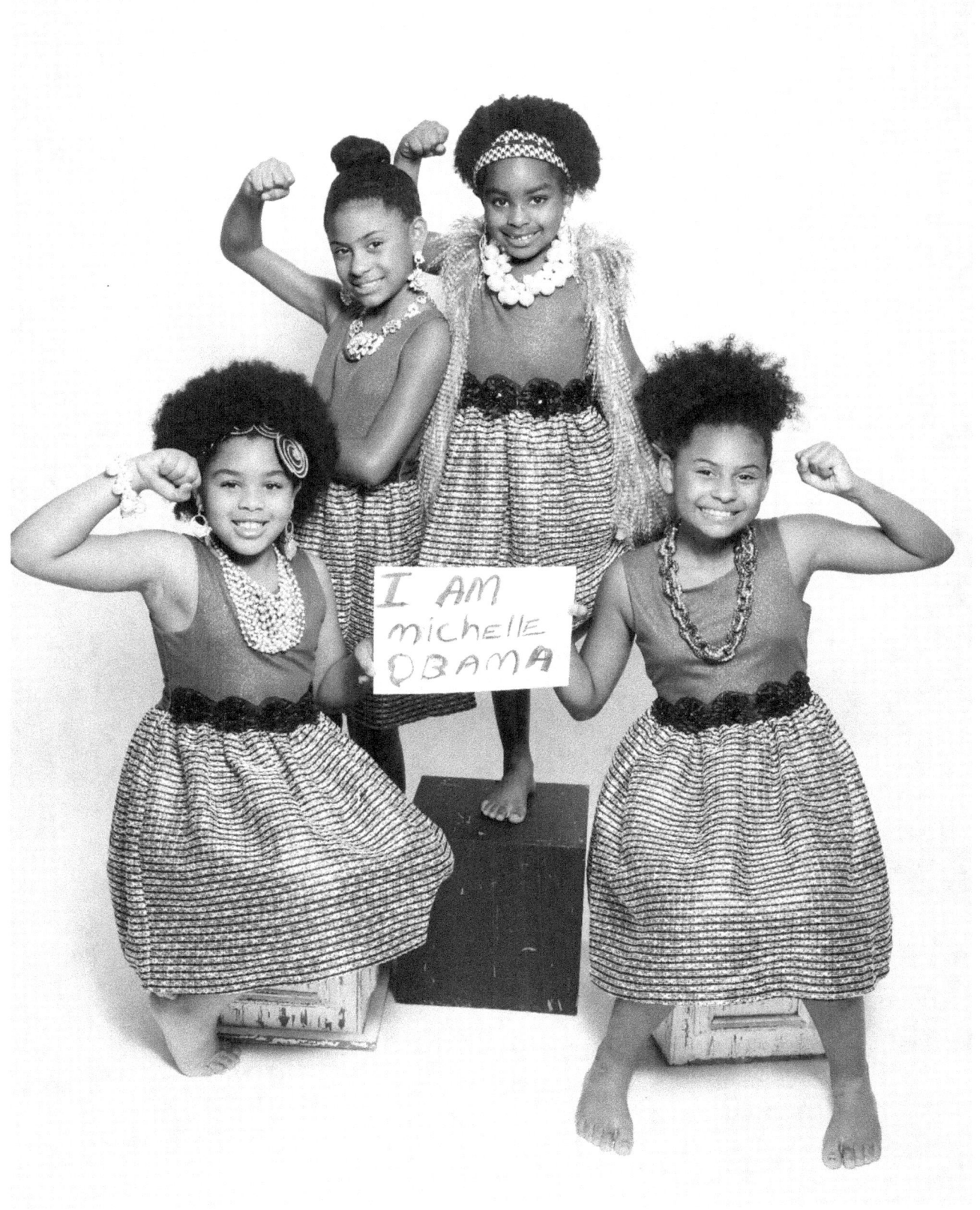

THE POWER OF O

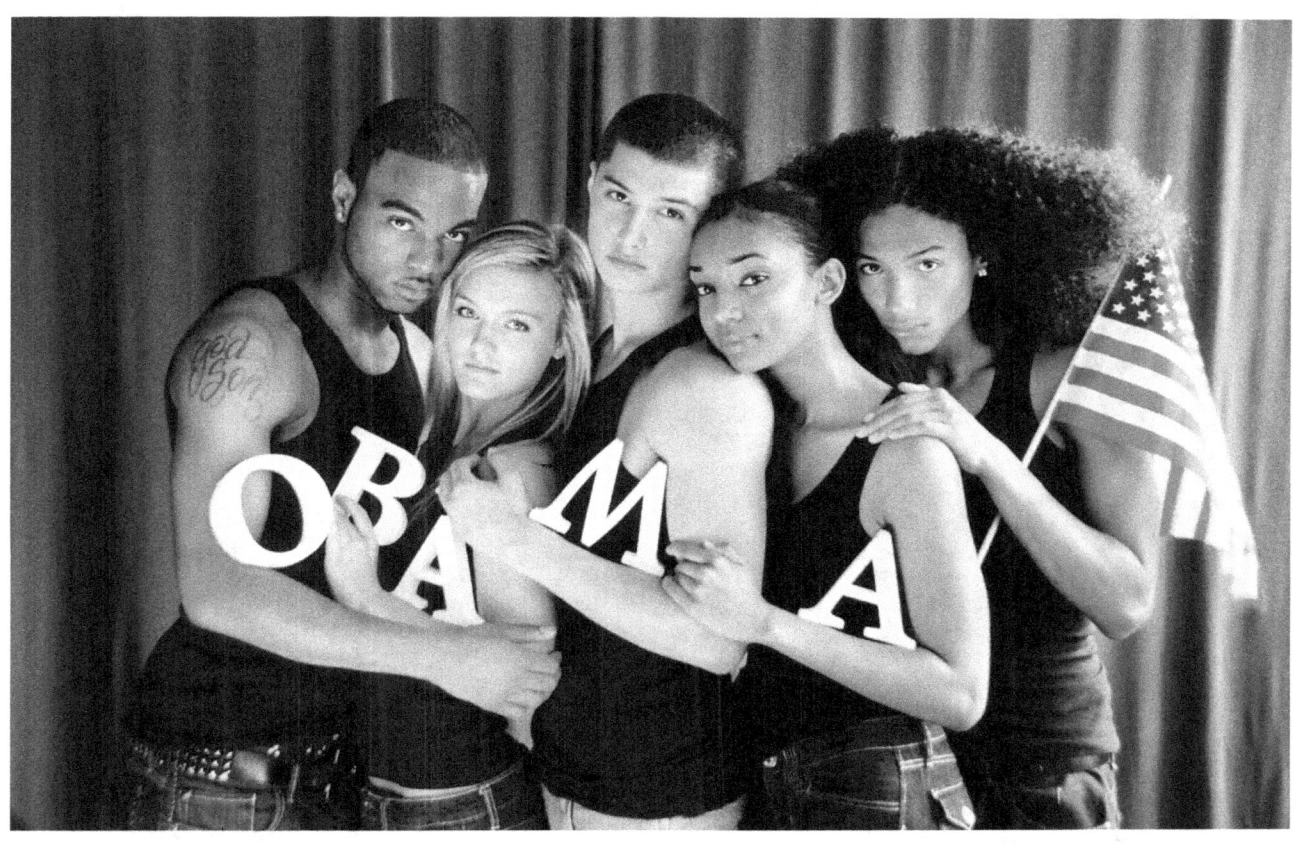

IN OUR LIFE TIME

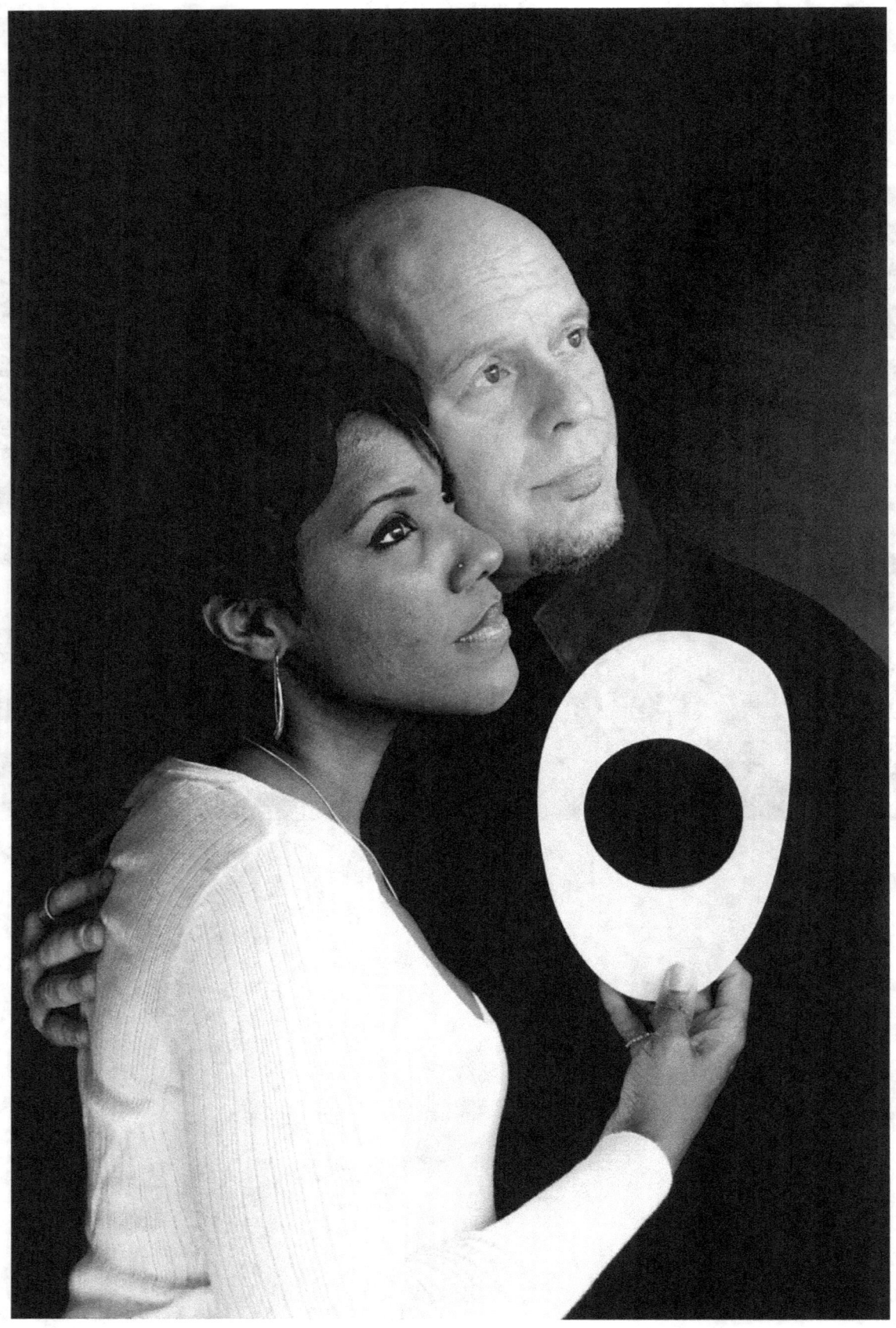

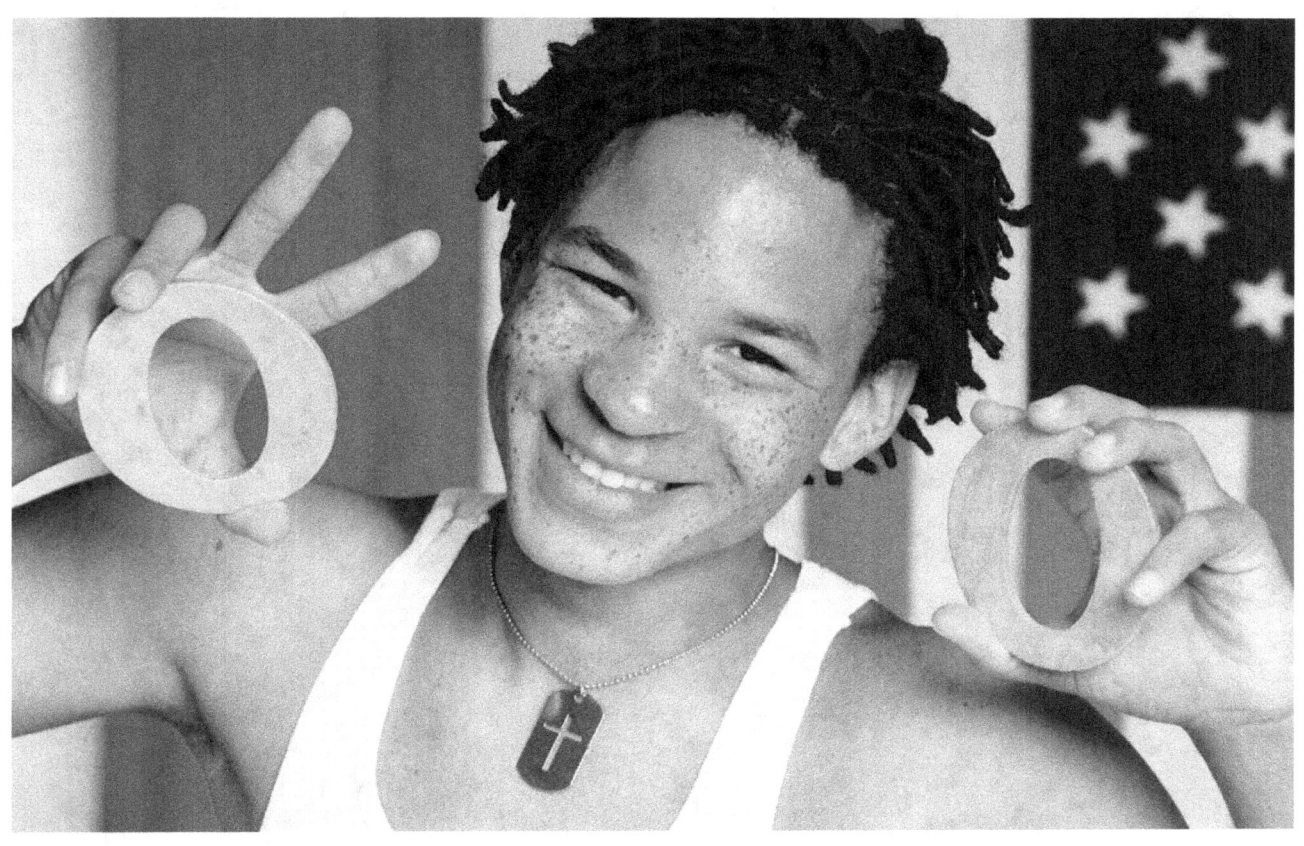

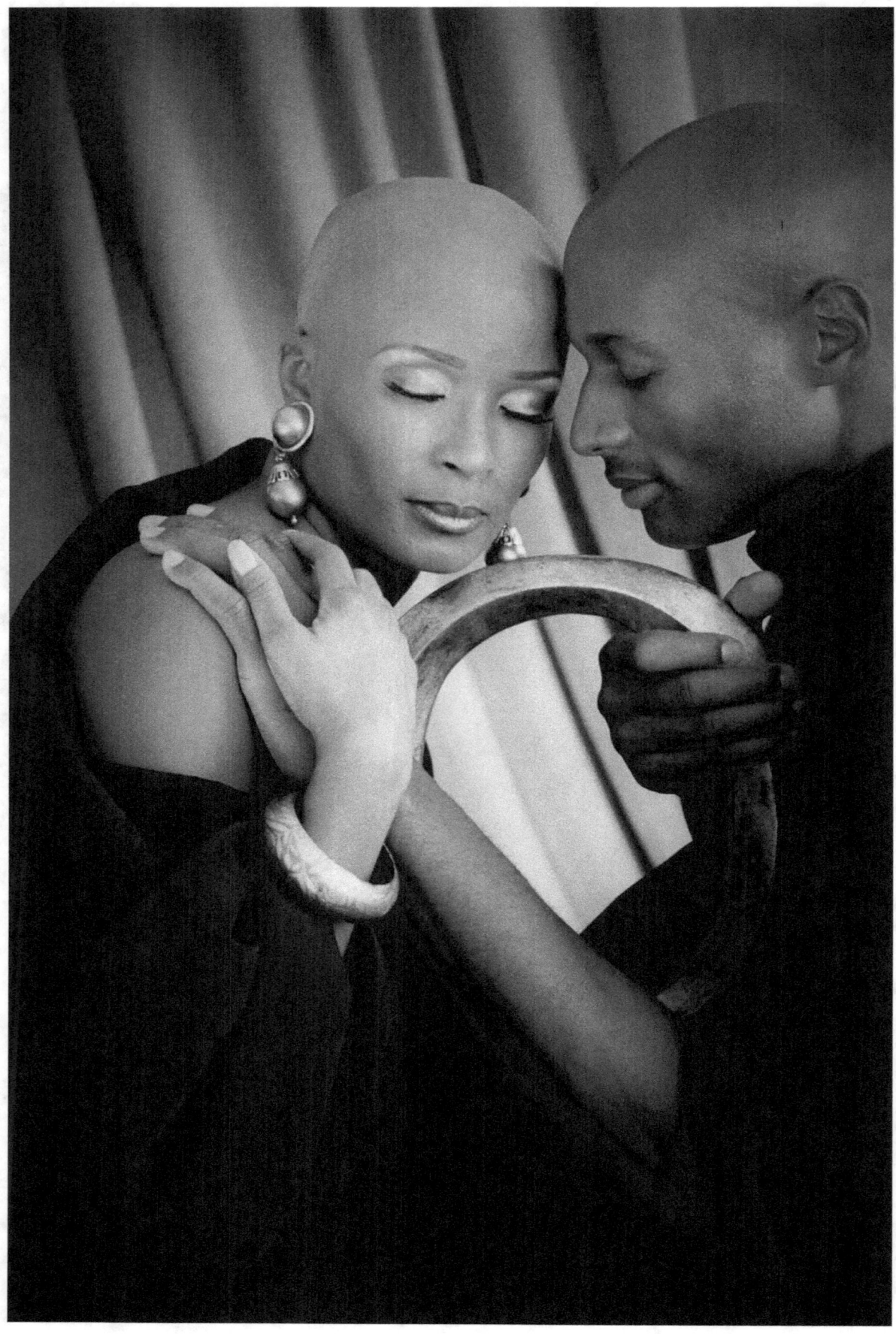

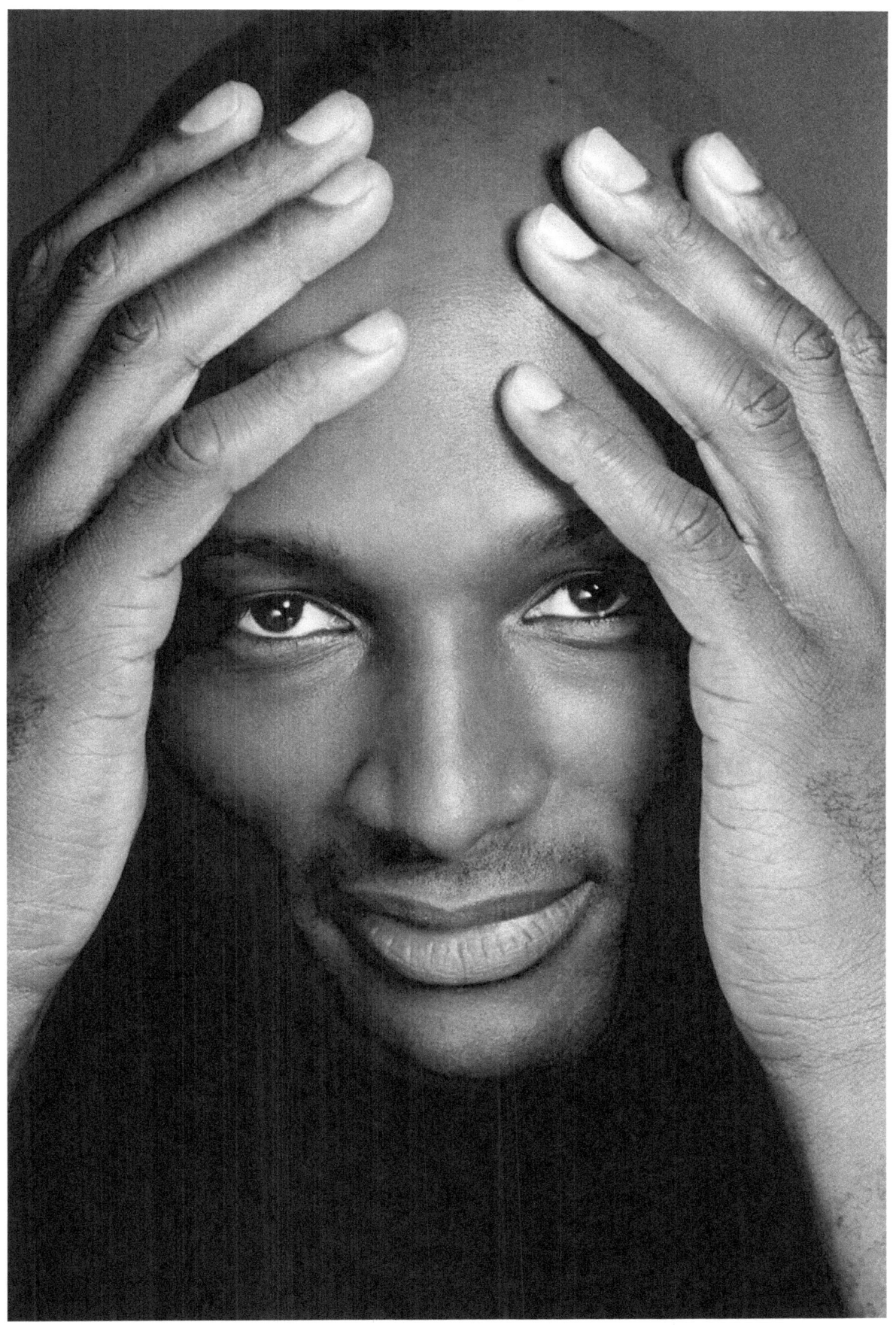

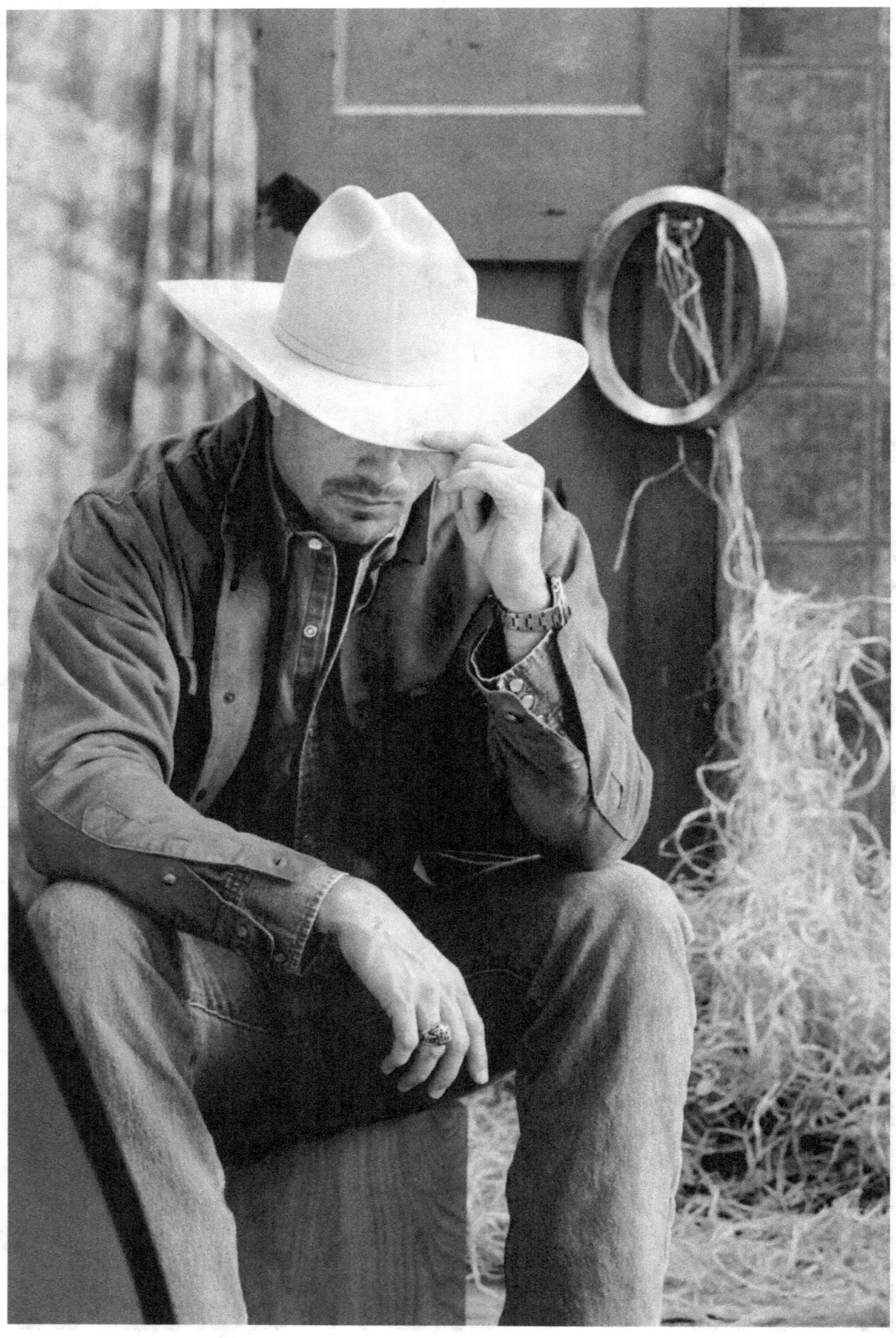

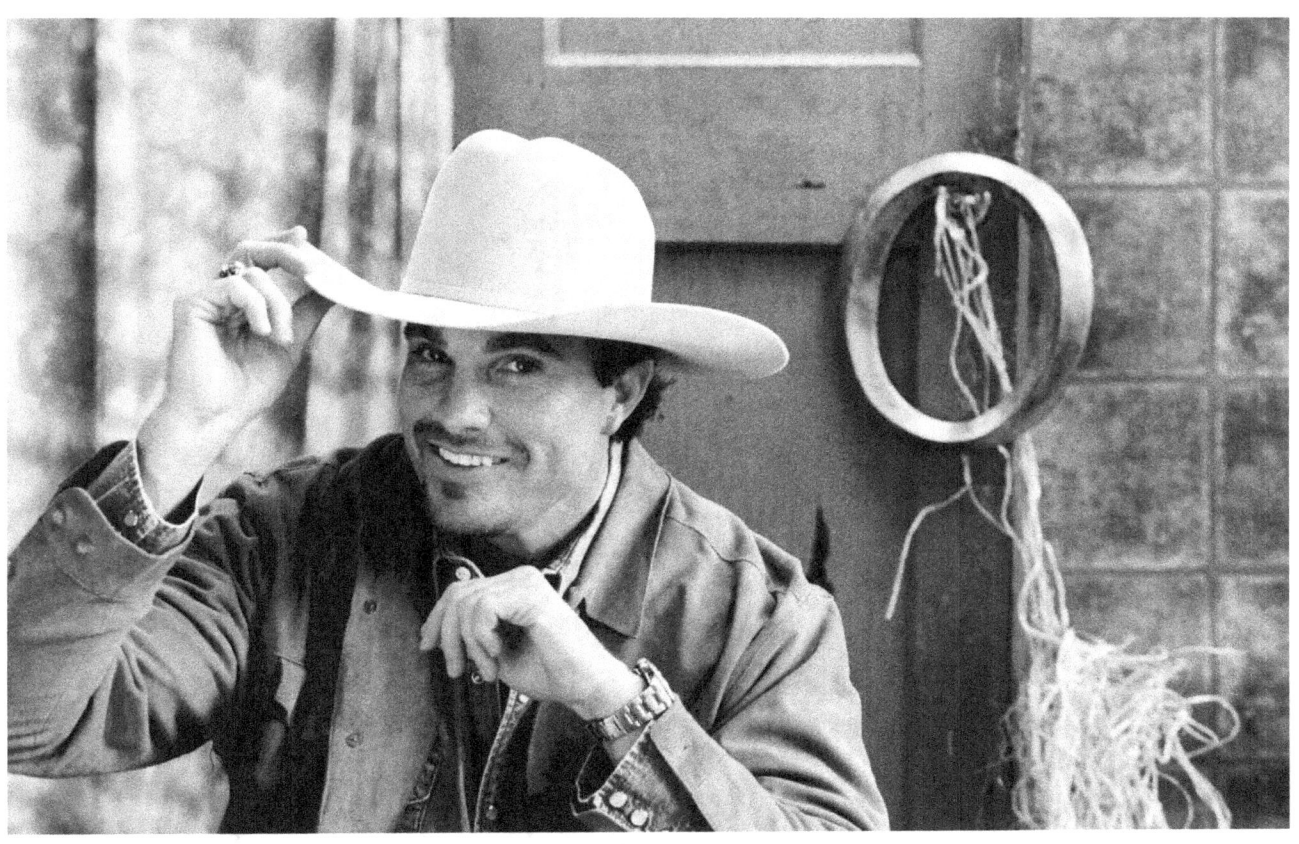

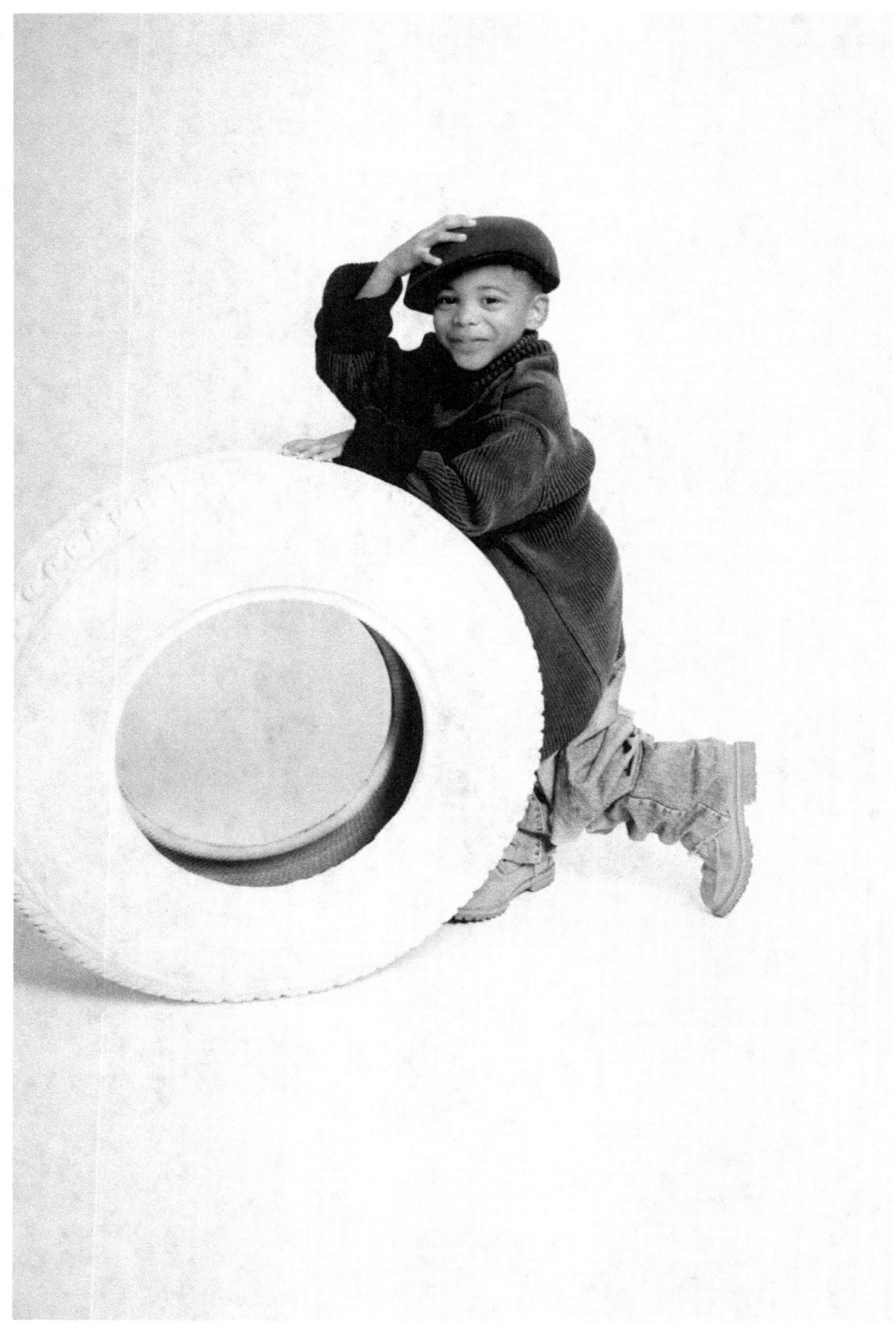

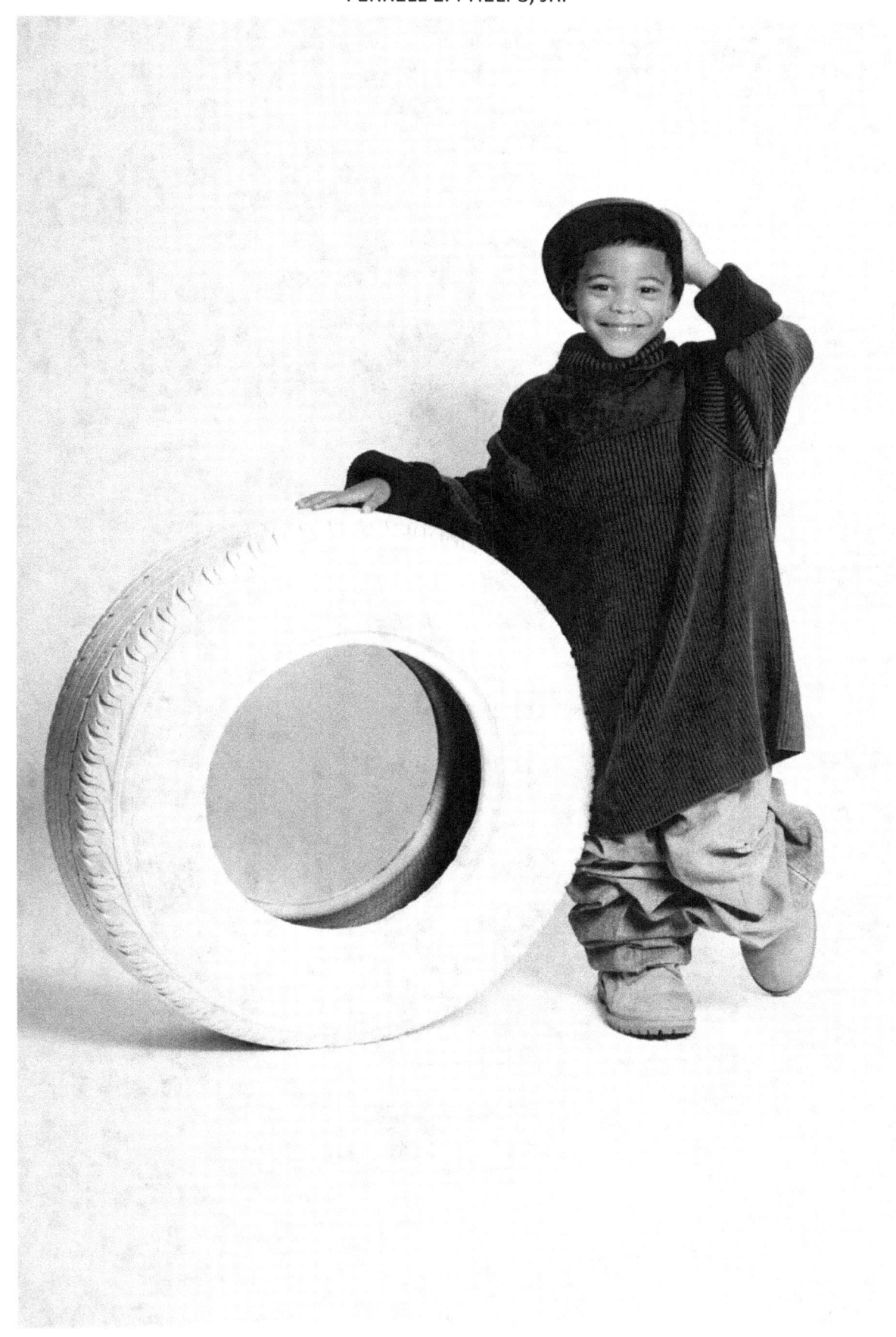

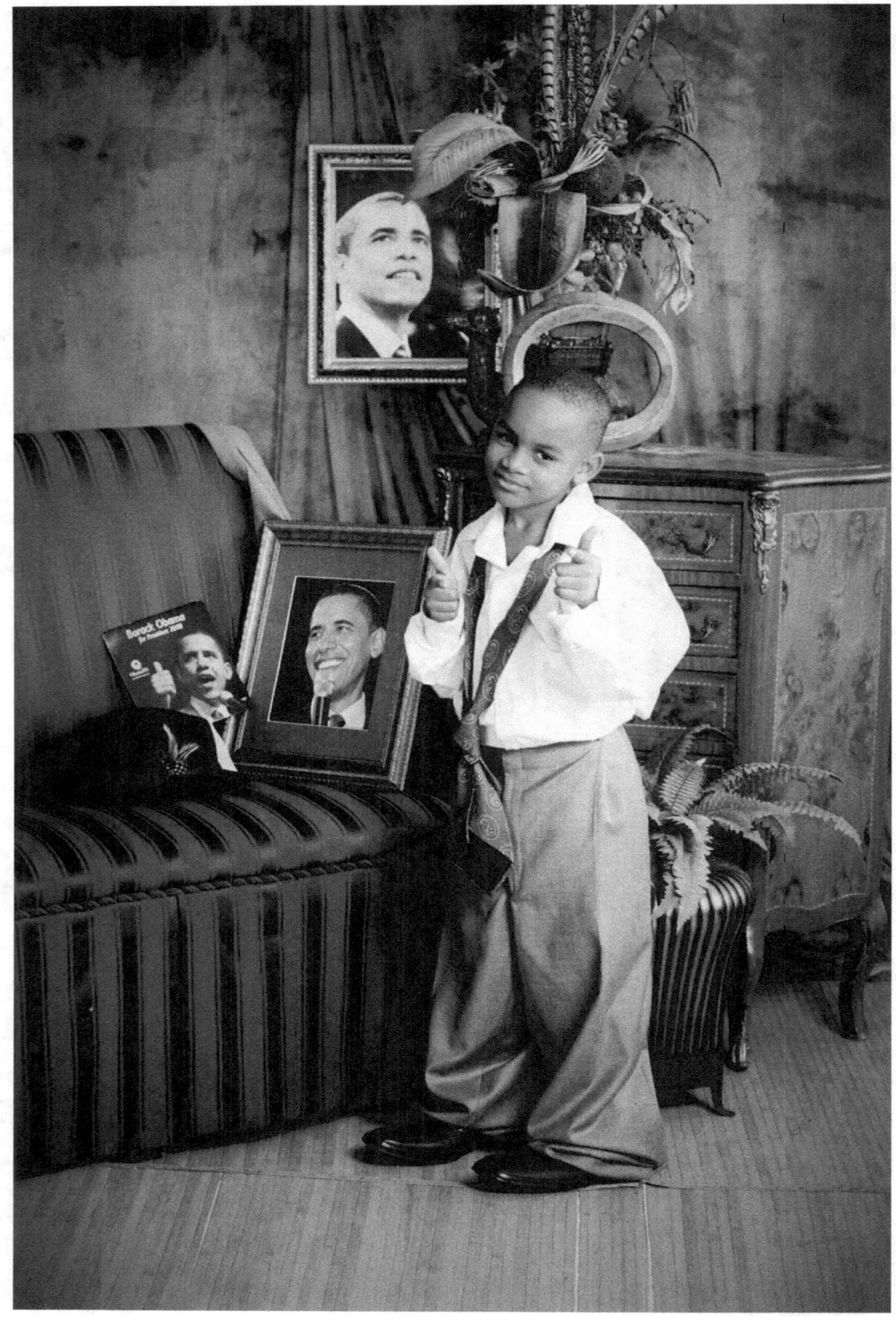

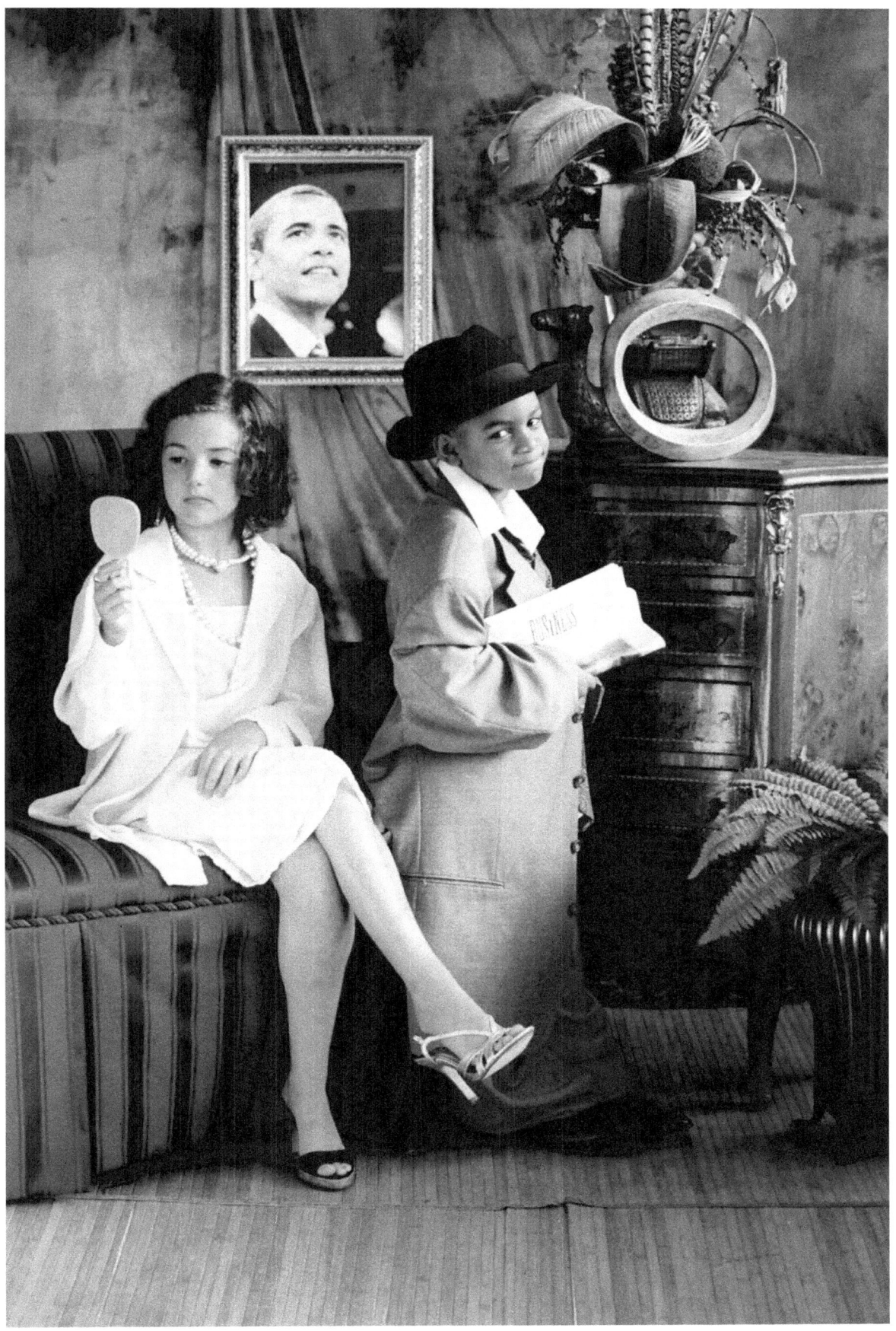

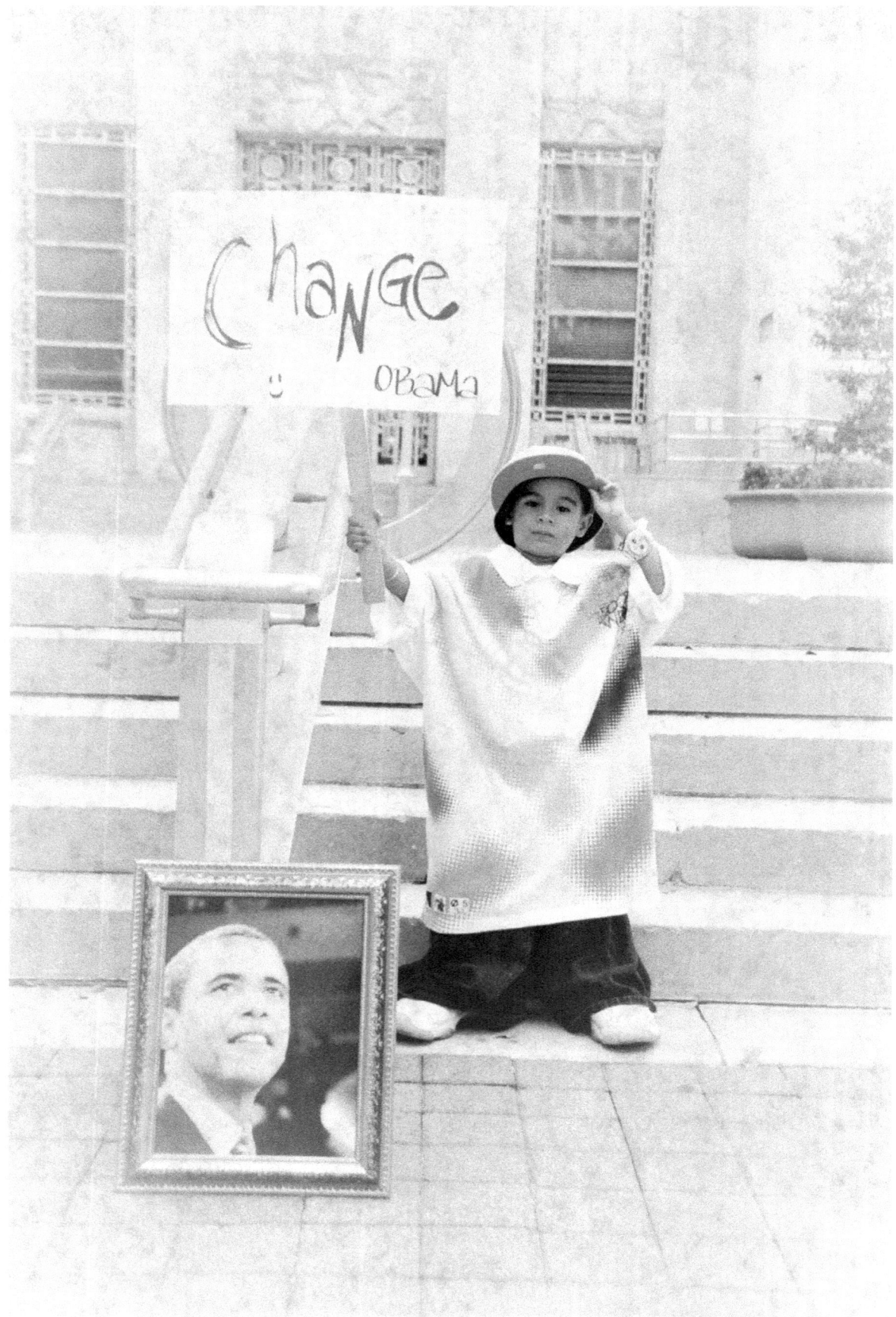

CHANGE

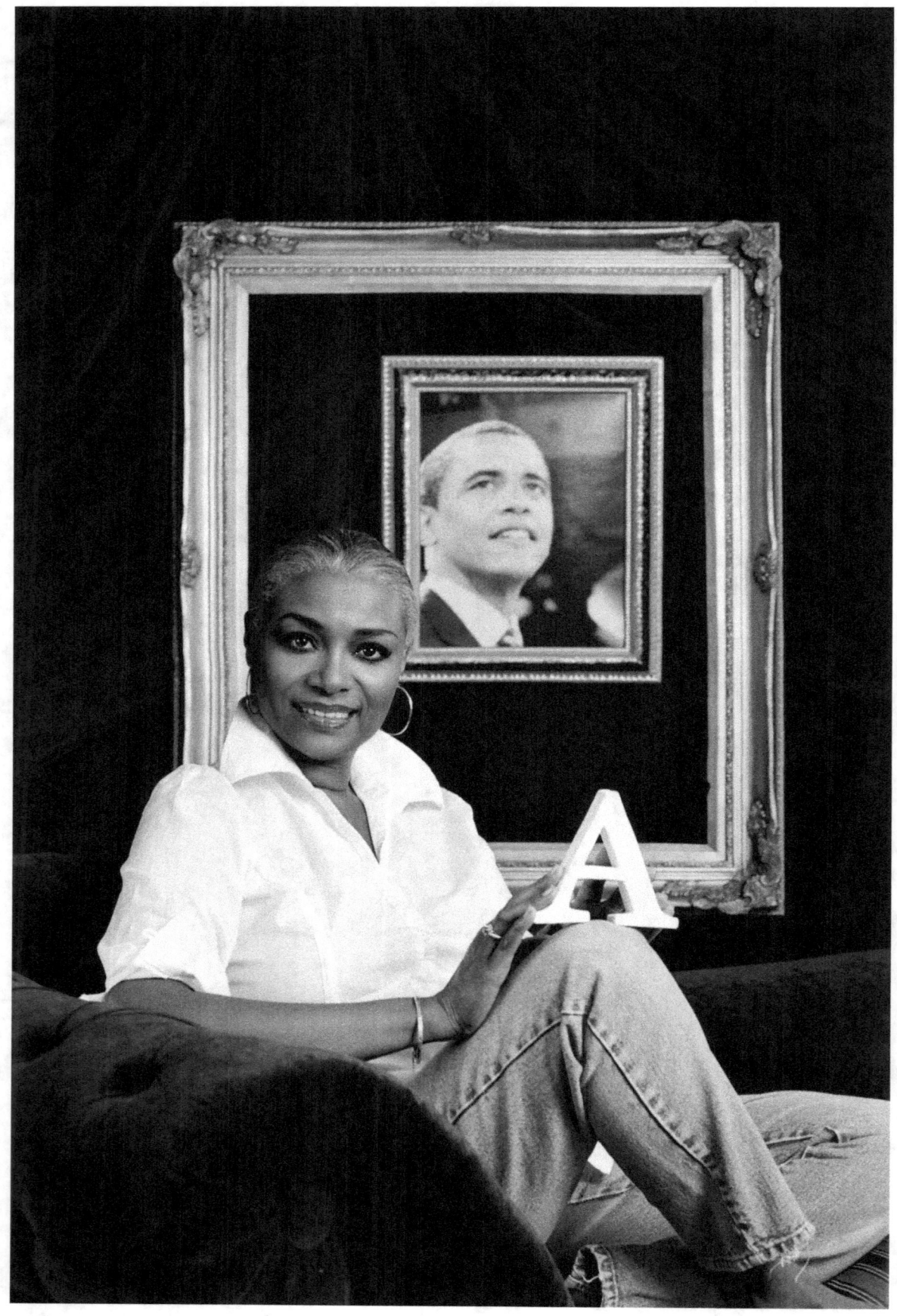

FERRELL E. PHELPS, JR.

ACHIEVEMENT

SPECIAL THANKS

TO ALL OF OUR MODELS, PHOTOGRAPHERS & ASSISTANTS

Homepage - Welcome to The Barack H. Obama Foundation
barackhobamafoundation.org

Welcome to the **Barack H. Obama Foundation** website. Home: Barack H. **Obama**: About the **Foundation**: Our Mission: Abon'go Malik **Obama**, Founder: Projects: Partner

1. Ferrell Phelps - YouTube

www.youtube.com/user/FerrellPhelpsShow

The Ferrell Phelps Show "Let's Talk About It "with Ferrell Phelps Jr. The Ferrell Phelps Show covers many topics ranging from humble beginnings of celebrity ...

2. Ferrell E Phelps | Facebook

https://www.facebook.com/ferrell.phelps

Ferrell E Phelps is on Facebook. Join Facebook to connect with Ferrell E Phelps and others you may know. Facebook gives people the power to share and

3. The Ferrell Phelps Freedmen's Town Documentary Project ...

https://events.khou.com/The_Ferrell_Phelps_Freedmen_s_Town...

Find details on The Ferrell Phelps Freedmen's Town Documentary Project Exhibit at khou.com

4. Ferrell Phelps | LinkedIn

https://www.linkedin.com/in/ferrell-phelps-5563766

Photographer at Ferrells photography ·
Photography ·
44 connections ·
Houston, Texas

View **Ferrell Phelps'** professional profile on LinkedIn. LinkedIn is the world's largest business network, helping professionals like **Ferrell Phelps** discover inside ...

5. The Ferrell Phelps Show "Let's Talk About It" - Home ...

https://www.**facebook.com**/pages/**The-Ferrell-Phelps-Show-Lets**-Talk...

The Ferrell Phelps Show "Let's Talk About It", Houston, Texas. 448 likes · 5 talking about this. **The Ferrell Phelps Show** covers many topics ranging from...

6. TheFerrellPhelpsShow (@FerrellPhelps) | Twitter

https://**twitter.com/FerrellPhelps**

a. 443 followers ·
b. 527 tweets

The latest Tweets from **TheFerrellPhelpsShow (@FerrellPhelps)**. **The Ferrell Phelps Show** covers many topics ranging from humble beginnings of celebrity guests, community